THE ST. CLAIR RIVER

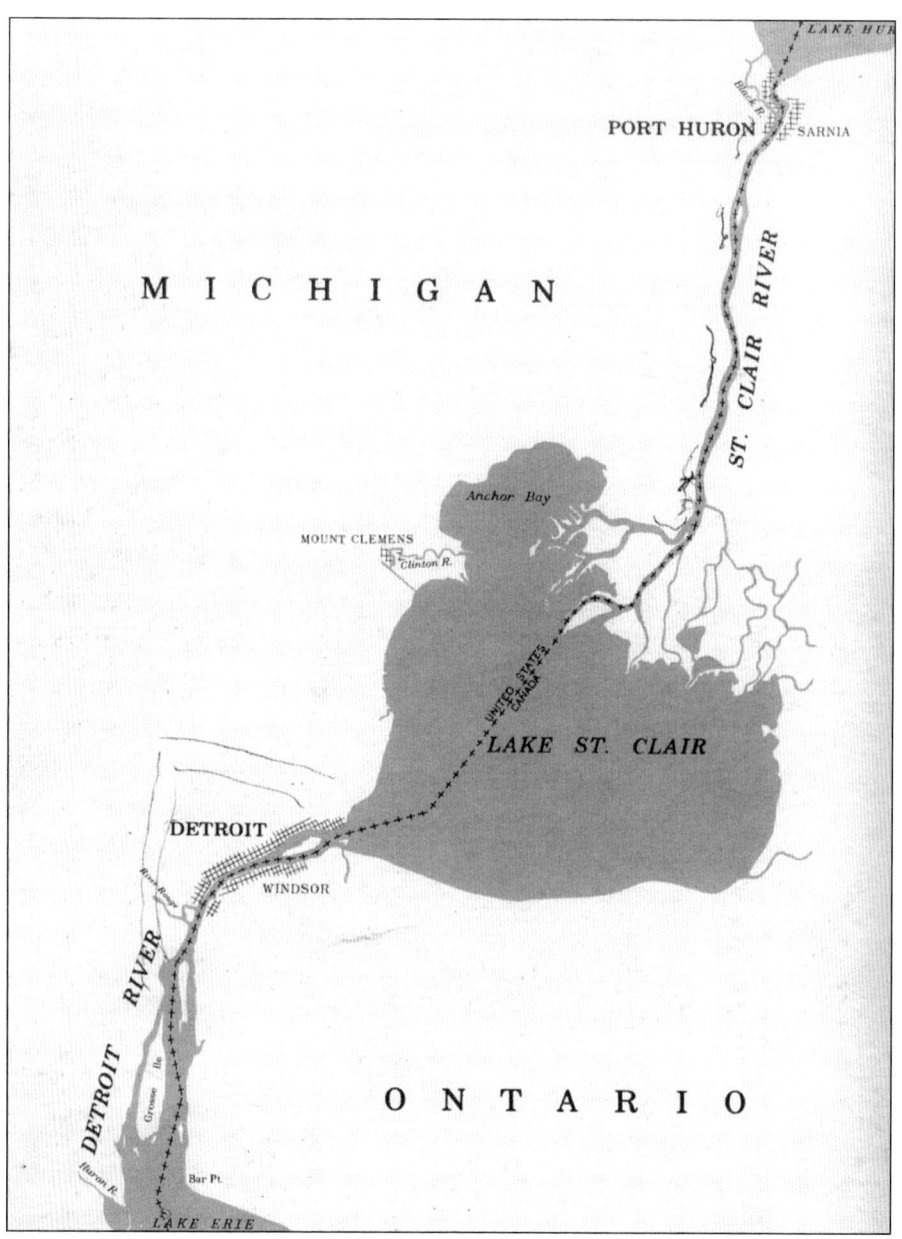

This excerpt from a 1985 US Department of Commerce "National Ocean Service" nautical chart shows how the St. Clair River connects Lake Huron (top) with Lake St. Clair (middle), part of the Great Lakes watershed system. Fresh water flows from the lakes north and west of Port Huron through the Detroit River into Lake Erie (bottom) on its way to the Atlantic Ocean. (National Oceanic and Atmospheric Administration.)

ON THE COVER: Illustrated here are three elements of the St. Clair River, Michigan, phenomena of the early 20th century: a summer cottage in the popular and picturesque bungalow style and an open-cockpit wooden-hull Chris-Craft motorboat, both pictured in a vacation Mecca of the period, the low-lying St. Clair Flats islands of the river's delta in Lake St. Clair, an area known for its many winding waterways as the "Venice of America." (Courtesy Algonac Museum.)

IMAGES of America
THE ST. CLAIR RIVER

Michael W. R. Davis

Copyright © 2011 by Michael W. R. Davis
ISBN 978-0-7385-8283-2

Published by Arcadia Publishing
Charleston, South Carolina

Printed in the United States of America

Library of Congress Control Number: 2010942239

For all general information, please contact Arcadia Publishing:
Telephone 843-853-2070
Fax 843-853-0044
E-mail sales@arcadiapublishing.com
For customer service and orders:
Toll-Free 1-888-313-2665

Visit us on the Internet at www.arcadiapublishing.com

Contents

Acknowledgments and Image Credits 6

Introduction 7

1. Pioneering the Northwest Territory 9
2. Historic River Traffic 19
3. The Seaway and Modern Shipping 39
4. Fruits of Land and Water 51
5. Vacationers, Cottages, and Homes 61
6. Suppliers of Goods and Services 77
7. Wooden Boat Builders 89
8. Manufacturing in the River Region 99
9. Other Transportation 109
10. Transformations 119

Bibliography 127

Acknowledgments

I was inspired to produce this book by two friends, Tom Geniusz and Doug Williams, who regaled me with their tales of life along the St. Clair.

The author is indebted to many persons who have helped with this St. Clair River book in small and large ways. They are listed below in the order of the image credit keys: Joan Bulley and Pat Fisher, Algonac Museum volunteers (A); Marlo Broad, Alpena City Library Special Collections (AC); Mark Bowden, Burton Historical Collection, Detroit Public Library (B); Ron Bloomfield, Bay County Historical Society-Museum (BC); Chrysler LLC Archives (C); Joel Stone, Detroit Historical Society (D); Diane Kodet, editor of *Thumbprint News*, who provided the aerial photograph of the Blue Water Bridge (DK); Doug Williams (DW), Cottrellville Township; Bob Kriepke, Ford Motor Company (F); Ned Eddins, DMV, Wyoming author, historian, photographer, and beaver expert (E); Bill Phillips and Chris Smith, Michigan Department of Transportation (H); Ken Schramm; Bill McKnight, I.E. Quastler, and Karl Heckman (KH), rail historians; Laurie Webb, County of Lambton, Ontario, Library (LL); Gary Beals and Larry Taylor, Marine City Museum (M); author's collection (MD); Patty Montgomery, Michigan Maritime Museum (MM); Michael Dixon, fellow author (MMD); Sarah Matuszak, Huron-Clinton Metroparks interpreter whose camera captured reenactors landing from Lake St. Clair (MP); Mike Skinner, whose personal collections have helped on previous projects as well (MS); Kim Coggins, Marysville Museum volunteer (MV); Gina Tecos, National Automotive History Collection, Detroit Public Library (N); National Oceanic and Atmospheric Administration (NOAA); Susan Bennett and Suzette Bromley, Port Huron Museum (P); Charles Homberg and Crissy Gorzen, St. Clair Museum (S); Tom Geniusz, Algonquin Club, who urged me to undertake the project and supplied many research materials and some images (TG); Tom Snider, who provided images from a previous book I coauthored (TS); Pat Higo, University of Detroit Mercy (U); Lt. Justin Westmiller, United States Coast Guard Belle Island station (USCG); James Cheevers and Dolly Pantelides, United States Naval Academy Museum (USNA); Larry Ann Evans, Wayne County, NY, Museum (W); Linda Boila, Erie Maritime Museum; Dr. Charles K. Hyde, Wayne State University history professor emeritus, who once again read over my manuscript; Frank Moore, St. Clair; Larry Sullivan, whose fishing boat brought me close to St. Clair Flats' waterside buildings; Art Woodford and Gary Grout, Harsens Island residents and historians; and of course my "computer widow," Karen, to whom I am much indebted, among many things, for her patience.

Introduction

The St. Clair River is one of the most scenic in America, remarkable since there are no hills to provide expanded vistas. Except for the dead of winter, when the St. Clair may be blocked by ice, the river's constant boat traffic, large and small, fascinates and enthralls. Today, there is nothing quite like watching a 1,000-foot-long bulk-ore carrier glide past, only a few hundred feet away. Two hundred years ago, the passing boats were canoes or sailing ships. One hundred years ago, the traffic consisted of both sailors and steamers, a few vessels with both sails and smokestacks, and newfangled small motorboats designed for recreation rather than commerce.

The purists insist that the St. Clair River is not a river but a *strait*, defined as a body of water connecting two large bodies of water, such as the Florida Strait between Cuba and the Bahamas on one side and South Florida on the other, connecting the Gulf of Mexico with the Atlantic Ocean.

By this definition, and usually cited first, the Detroit River is a strait. That makes straits also of the Niagara River and the St. Lawrence River, far downstream from St. Clair and Detroit. Few people think of either of those eastern rivers that way, especially the Niagara—whether above or below the falls.

Historical accounts say "St. Clair River" is a fairly late name for the link between Lake Huron and Lake St. Clair northeast of Detroit. The Chippewa Indian Nation tribes of the area called it Otsiketa-sippi. French explorers arriving in the early 17th century labeled it Huron River, after the lake from which it flowed. Then it became known as the Sinclair River, for Lt. John Sinclair of the English army, who built a fort at the mouth of the Pine River in 1764 after the British vanquished the French in the French and Indian War of 1754–1763.

When Americans arrived in the early 19th century, Sinclair became St. Clair, both because the early 17th-century French explorers had named the lake into which the river flows "Lac Ste. Claire" and the first US governor of the new Northwest Territory had been Revolutionary War hero Gen. Arthur St. Clair. And thus it has been branded the St. Clair River ever since.

Nearly 200 years later, the St. Clair River "highway"—with its traffic mixture of pleasure boats, lakes-only commercial shipping, and ocean-going "salties" coming from around the world via the St. Lawrence Seaway—is arguably one of the busiest such routes in the world, even though the number of lake-only ships has been sharply reduced.

Accordingly, this book relates the common history of all the communities on the lake's western (Michigan) shore, beginning with the changing traffic on the river. It goes on to describe photographs depicting natural resources of the area; the scenic and recreational attraction for vacationers, weekenders, and commuters; growth of community infrastructures, such as stores and schools, to serve both river traffic and the growing population; boat builders and other manufacturing; arrival of other forms of transportation; and finally transformations from historical to modern times. These developments were largely common, working from south to north along the river, for the Flats, Algonac, Marine City, St. Clair, Marysville, and Port Huron.

What are the dimensions of the St. Clair River? This is almost as confusing as the origin of its name. Officially, the length of the river is 39 miles, presumably the shortest distance on the river from the Fort Gratiot Light House at the south end of Lake Huron to where it flows freely into Lake St. Clair. But if you drive from the Light House to the Old Club at the south end of Harsens Island, the shortest distance is 43 miles; just to Algonac where the river splits into North and South Channels at the Flats, the distance is 31 miles by road. The width varies from 500 to 3,000 feet and a minimum depth of 27 feet at low water is maintained in the main channels.

The international border between the United States and Canada goes down the middle of the river, except for the St. Clair Cutoff channel that is entirely in Canada, a section created for the Seaway at the south end of the river. Here the border remains in the middle of the old South Channel along Harsens Island west of man-made Seaway Island created by excavation for the short cut. As a consequence of its relatively narrow width, the river has long attracted illegal crossings of goods and people between the two countries, which in turn leads to extensive surveillance, both direct and remote, by US Border Patrol personnel. US and Canadian Coast Guard boats also patrol the river to maintain navigation safety.

From Lake Huron to Lake St. Clair, the elevation drops five feet, creating a southerly current of five miles per hour. Bucking the current creates a challenge for sailboats traveling upriver. Today, tacking is undesirable because it might be dangerous among huge ore ships or salties going either direction through the channel in the river's middle. Auxiliary inboard or outboard engines for sailboats became very popular in the 20th century. Shallow shoals, especially on the east, or Canadian, side of the river also present a hazard to small boats avoiding the channel.

As noted above, the land on either side of the St. Clair River is essentially flat, though on the American side, it rises several feet at the north side of St. Clair. In geologic history, the area was once part of a sea bottom (source of salt deposits), later covered by ice sheets, which gradually receded, creating today's lakes and rivers.

In addition to being a highway for maritime traffic, overhead, the river is a major route for bird life migrating to and from southerly winter quarters. Migrating geese and ducks have provided food and sport for centuries. Local food and game fish historically have included bass, perch, lake trout, pike, and pickerel, but commercial fishing now takes place in the Canadian waters of Lakes Huron and Erie, rather than in the river.

One
PIONEERING THE NORTHWEST TERRITORY

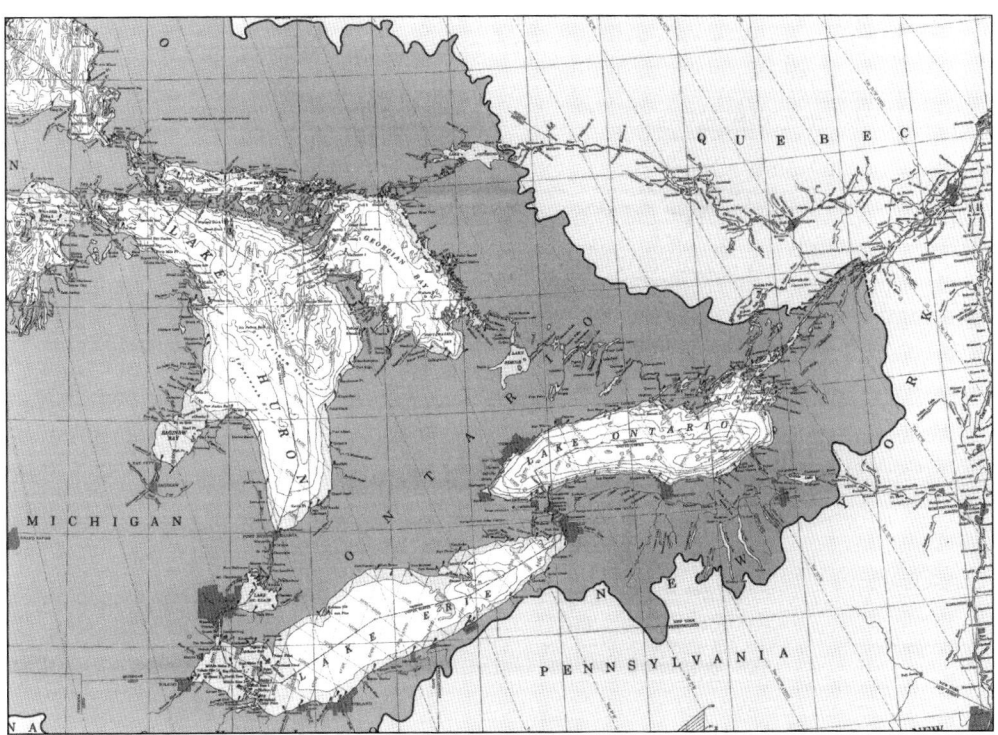

The northern route taken by the first-known European explorers of the St. Clair River can be traced on this navigation chart covering the eastern Great Lakes watershed. Early 1600s French trappers/traders/missionaries likely canoed westward from Montreal up the Ottawa River (top), across Lake Nipissing, down the French River to Georgian Bay, thence southward through Lake Huron to the point where it emptied into the St. Clair. (NOAA.)

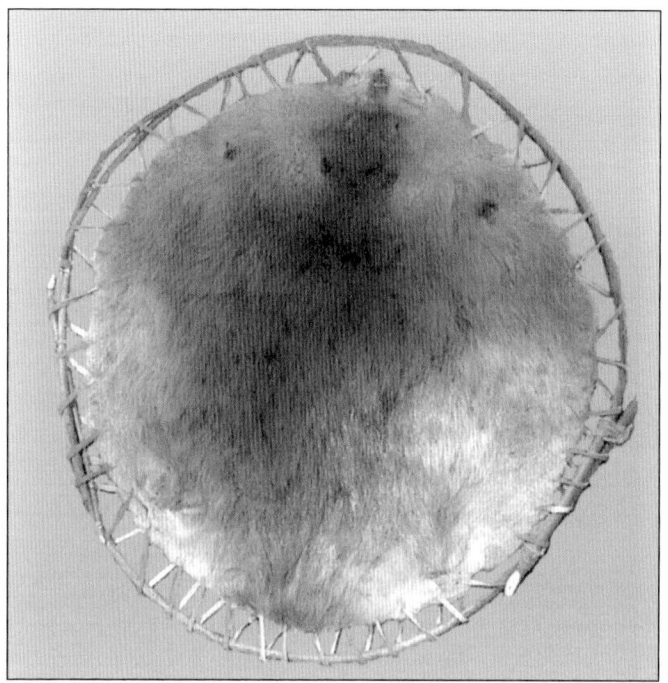

New France (Canada) fur traders sought beaver pelts like this, skinned from the small water animal, and mounted in a willow-branch holder. Beavers can grow to 100 pounds, but those trapped usually weigh around 50. Their skins were a fad in Europe for some 200 years, used for men's hats. As European beavers became scarce, North American sources attracted Continental investors, fueling French colonization of Canada. (E.)

Beavers gnaw down young trees to construct waterside lodges like this (center) or, more troublesome, dams across creeks and rivers, resulting in flooded streams and complaints in modern times from farmers, land owners, and others concerned with the consequences of beaver activity, including the destruction of valuable young trees. But dams are a boon to beaver hunters, who readily locate their prey near the beaver homes. (E.)

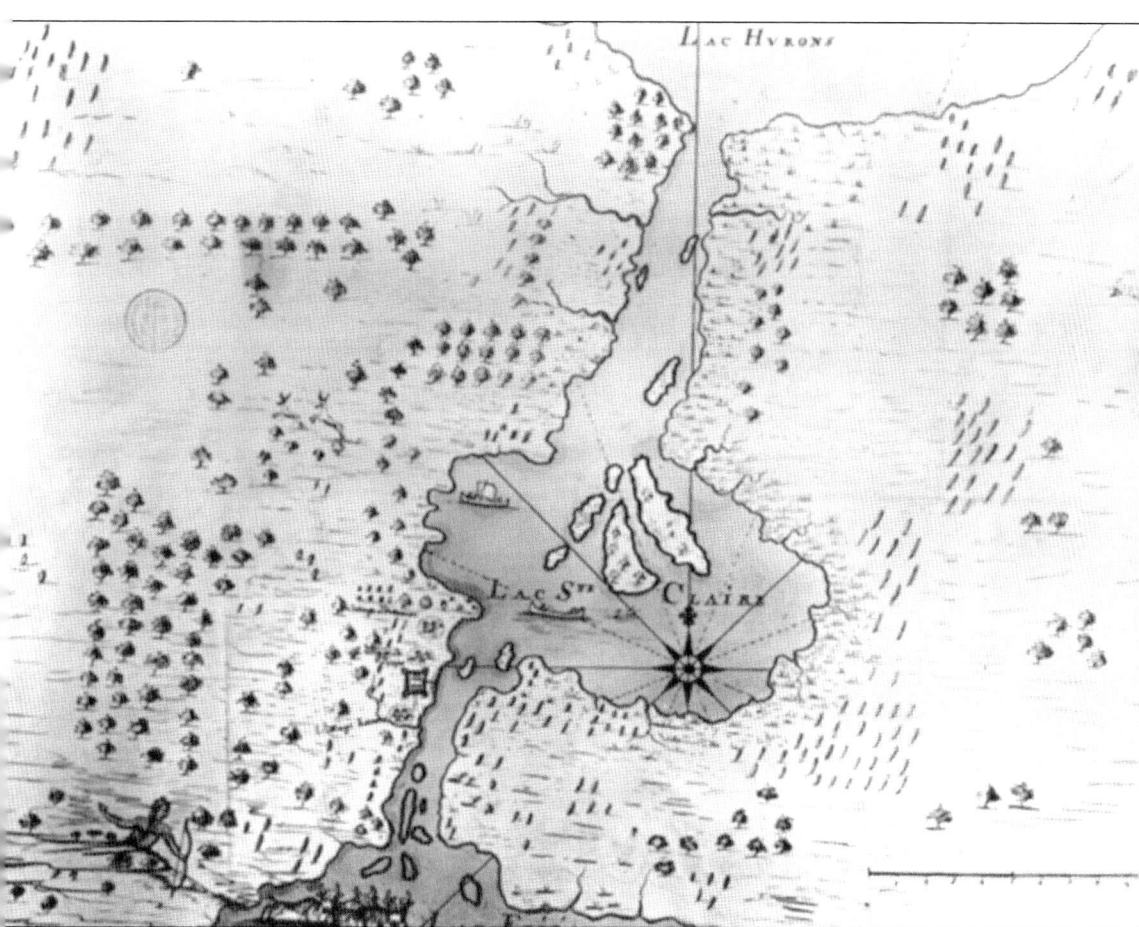

Lacking modern tools like today's satellite cameras or even precise navigational aids, 17th-century mapmakers were only generally correct in their charts of the newly explored lands of North America. This mid-1600s French map of the region between Lake Erie and Lake Huron exaggerates the widths of the Detroit and St. Clair Rivers as well as the channels between islands in the waterways. Likewise, those islands are shown to be far larger than they presumably were at the time. If anything, due to accumulations of silt and dredging for safe navigation, the low-lying islands constituting the St. Clair Flats in the delta of the St. Clair River where it empties into Lake St. Clair are larger now than they were 400 years ago. (B.)

Traditional birch-bark canoes were the principal, indeed virtually only, means of transportation in the lakes and rivers of the Great Lakes watershed when Europeans arrived on the scene in the 1600s. Fashioned by Native Americans/First Nations peoples as shown here, canoes were quickly adopted by French and, later, British explorers. (B.)

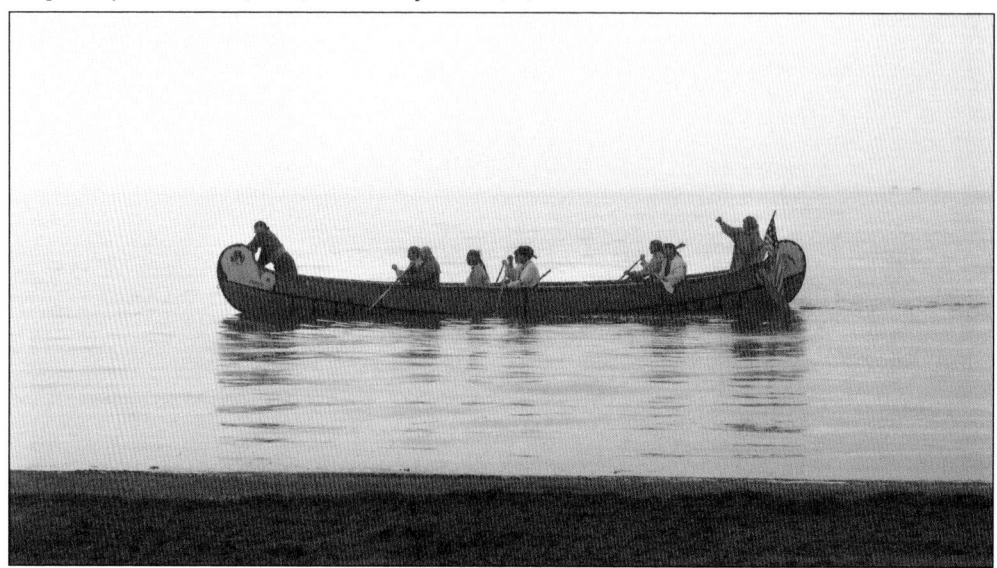

Larger canoes, like this reproduction seen in Lake St. Clair in 2010, were developed to carry more men and especially cargo like trade goods outbound and beaver pelts returning. Reenactors used this canoe to recreate the 1820 landing near Mount Clemens of Michigan territorial governor Lewis Cass. It carried nine men plus cargo. The portability of canoes allowed them to be carried across obstacles including small landmasses. (MP.)

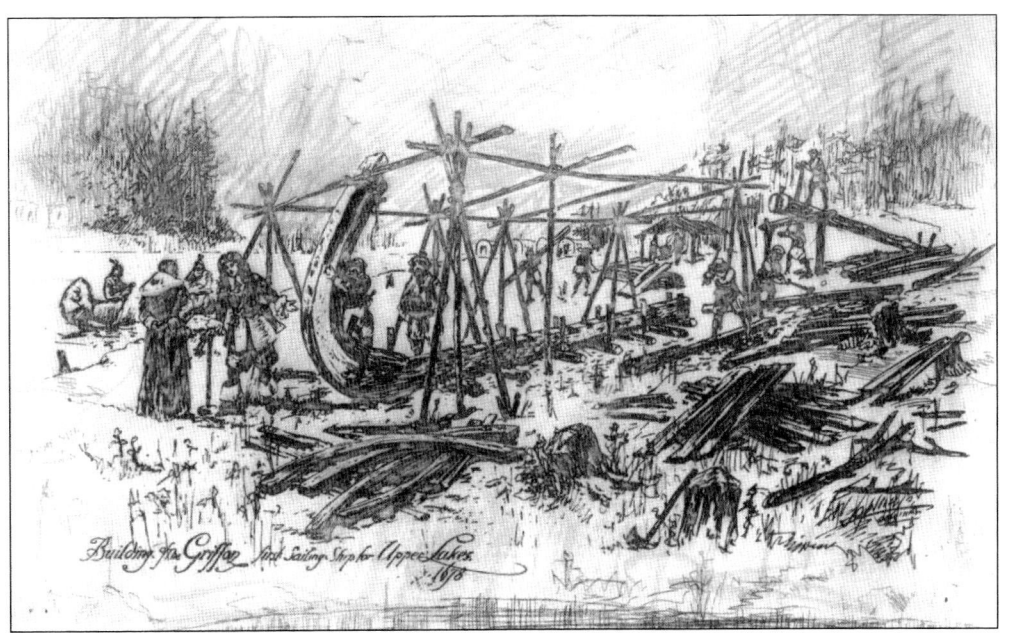

Sailing vessels came to the Great Lakes west of Niagara in 1679 when French explorer Robert LaSalle and missionary Fr. Louis Hennepin hired Native Americans to build the *Griffon* on the shore of Lake Erie near modern-day Buffalo. This painting depicts the construction process. It constitutes one of the earliest examples of material culture transfer from Europeans: wood-frame sailboats, eventually to replace birch bark canoes on open waters. (B.)

Within weeks of its launch, the 65- to 70-foot-long brig *Griffon* was lost in a storm on Lake Michigan and, because of the vessel's historic significance, artists ever since have sought to illustrate the first sailing ship on the inland seas. This 20th-century rendering is both skillful and likely historically accurate, in that it resembles known 17th-century European trans-Atlantic ship representations as captured by artists of the time. (D.)

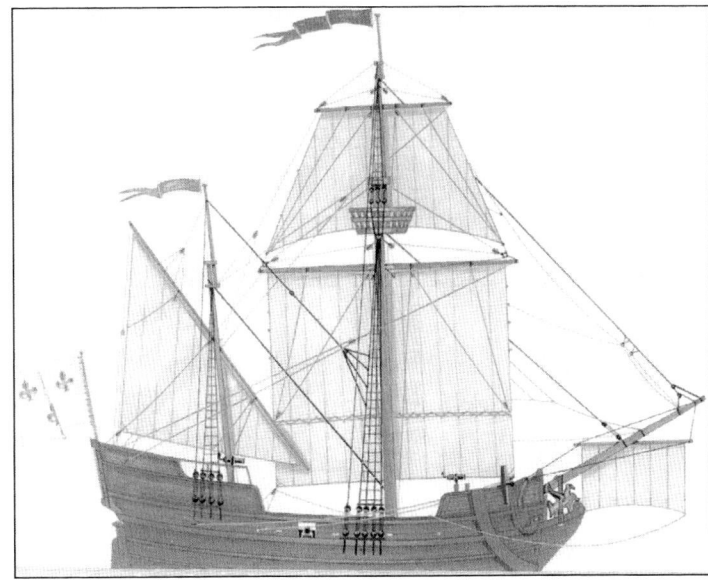

13

French Roman Catholic missionary priests accompanied explorers and traders into the western Great Lakes, establishing outposts for European civilization and religion. This painting depicts a late 17th-century mission (note the cross) near today's Sault Ste. Marie where Lake Superior flows through the St. Mary's River into Lake Huron. It shows a mixture of European and native housing: a log house and Indian lodges with animal skin coverings. (B.)

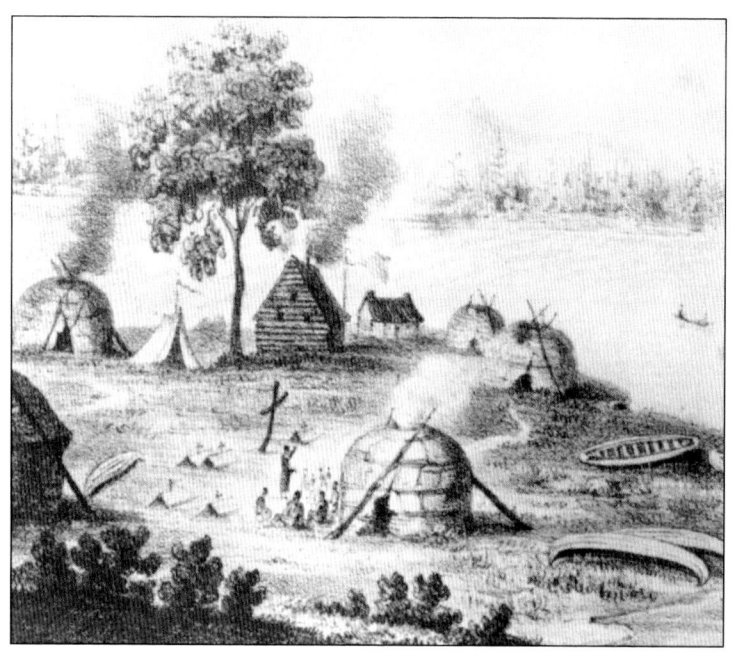

In 1686, the French established Fort St. Joseph as a way station at the head of the St. Clair River, under what is now the American side of the twin-span multilane Blue Water highway bridge connecting Michigan and Ontario. This plan, illustrating Fort Joseph's simple layout and its relation to modern streets and the bridge, is mounted on the wall of the St. Clair Museum. (MD.)

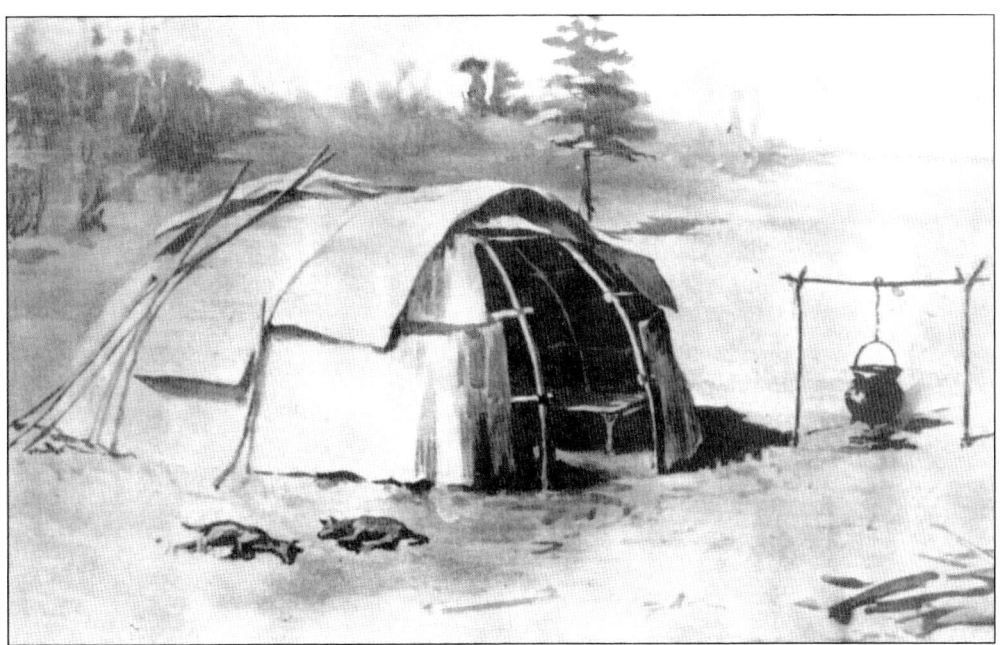

This painting of a Menominee tribe wigwam, covered with animal skins and a European iron cooking pot outside, illustrates a benevolent impact of Europeans on the Native American/First Nations people of the Great Lakes. French fur trappers probably traded the ironware for beaver pelts, or missionaries might have provided the durable, easily transportable cooking pot in a gesture of friendship. (B.)

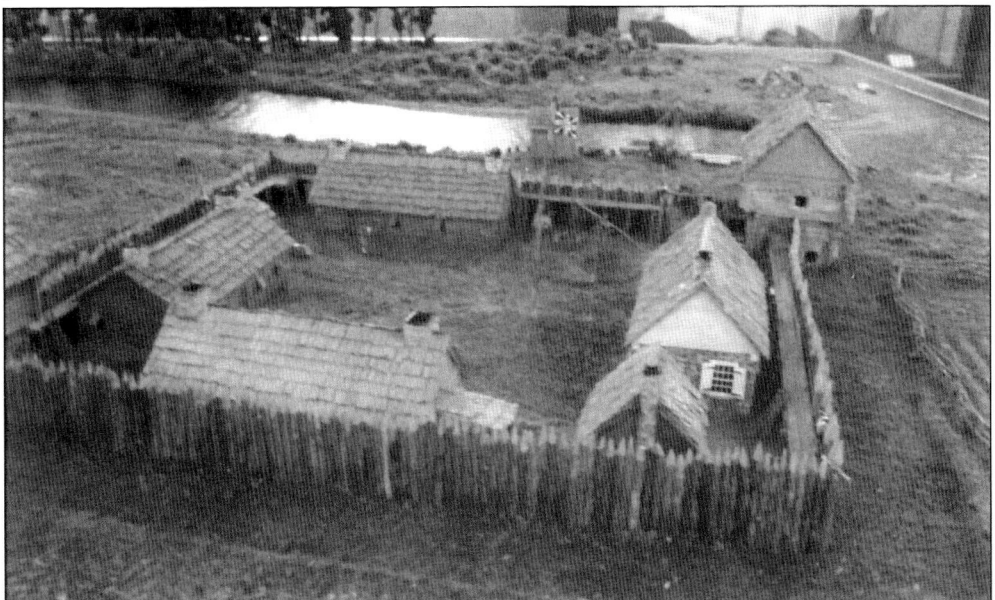

Nearly a century later, after England's victory over France in the 1754–1763 French and Indian War, the British took over France's North American colonies, moving westward into the Great Lakes. In 1764, British Lt. John Sinclair established Fort Sinclair where the Pine River joins the St. Clair. This model of the fort is in the St. Clair Museum. Today a giant salt manufacturing plant occupies the fort's site. (MD.)

As a result of the American Revolution, in 1783 the British ceded their lands south of what became Canada to the new United States. But British commercial interests were reluctant to abandon their prosperous trade in the region, and continued to dominate by occupation or trade what was now US territory. Eventually this led, among other factors, to the War of 1812 between the United States and Great Britain. The turning point in the West was America's August 1813 victory in the Battle of Lake Erie, depicted in this painting. It was a crucial turning point in the history of the St. Clair River, opening the area to American settlers. (USNA.)

Steam engines were invented in England in the early 18th century to pump water from coalmines, migrating to other uses in later decades. John Fitch of Philadelphia demonstrated the first American steamboat in 1787. After the Northwest Territory was opened to Americans at the end of the War of 1812, the first steamboat on the Great Lakes was launched at Buffalo on Lake Erie in 1818. This painting of the Lakes' first steamer, the 135-foot *Walk-in-the-Water*, being forced ashore in eastern Lake Erie in 1821, depicts one of the hazards of Great Lakes navigation. The ship was lost but the engine was salvaged for use in other ships. As the 19th century progressed, continual advances in steam engine technology led to railroads, steam-powered sawmills, and eventually steam-driven paddlewheels replacing sails on the Lakes. (D.)

Opening of the Erie Canal across western New York state in 1825 became the key to population settlement of Michigan Territory following the War of 1812. Canal travel was slow but relatively inexpensive and safe. This mid-19th-century photograph of the Erie Canal at Lyons, between Syracuse and Rochester in western New York state, shows a mule, used to pull the canal boat, being led ashore to the towpath alongside. As well as providing a route for migration, goods, and other cargo, the Erie Canal created prosperity for farmers, merchants, and manufacturers along its route. Yankees from New England swarmed via the canal and sailing ships or steamships across Lake Erie to settle along the St. Clair River of Michigan. An American fort built at Fort Gratiot on the upper St. Clair in 1815 was deemed unnecessary and abandoned in the 1820s. (W.)

Two

HISTORIC RIVER TRAFFIC

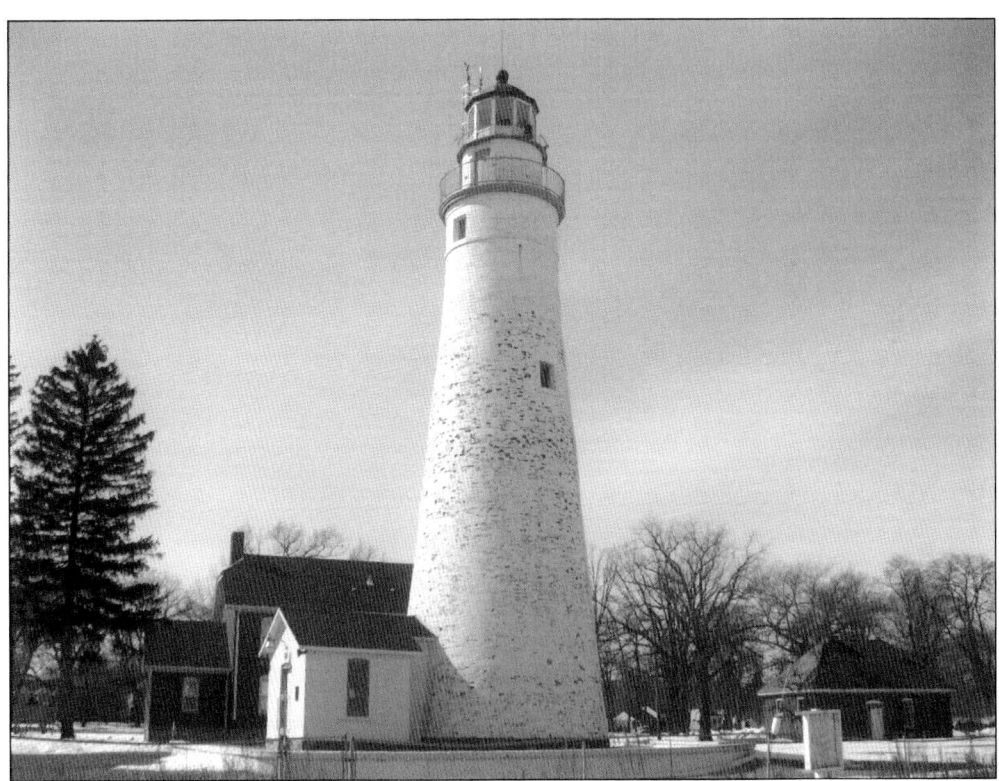

The Fort Gratiot lighthouse on Lake Huron marked the northern entrance to the St. Clair River. The 1839 Fort Gratiot light, like others in the Great Lakes until modern times, provided for a live-in lighthouse keeper and his family. These lighthouses, and those on the Atlantic and (later) Pacific coasts, were established by the US government to make navigation safer. Today's automated lights mark dangerous shoals and navigation channels. (P.)

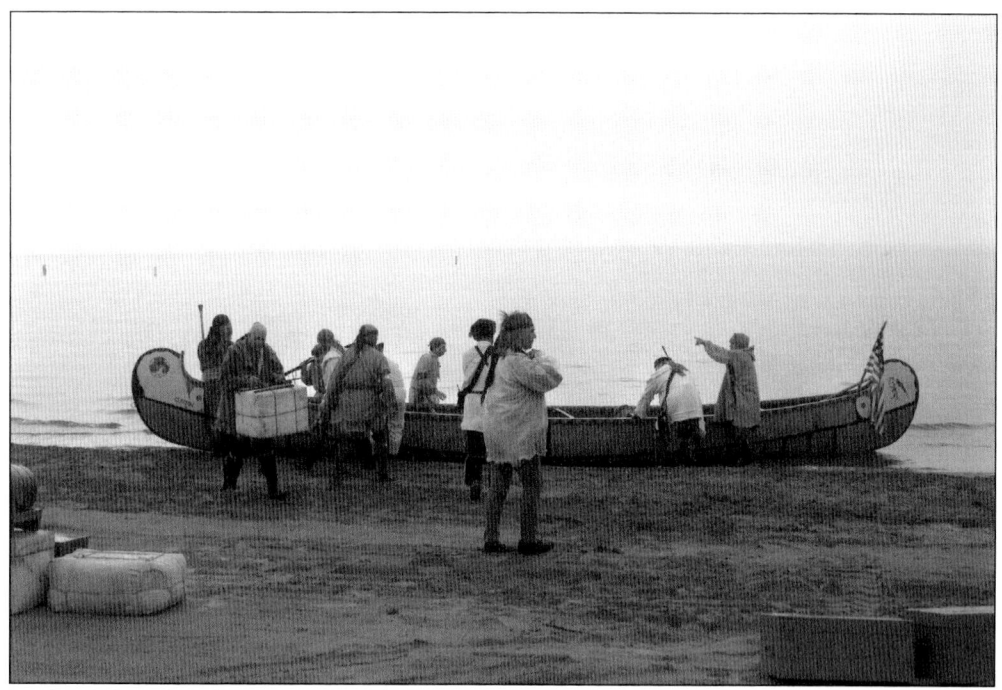

In the 17th and 18th centuries, explorers, missionaries, soldiers, traders, and trappers traveled through Great Lakes waters in cargo, or "Montreal" canoes like the one shown here being unloaded by 21st century reenactors on Lake St. Clair. Such large canoes were the first freighters regularly plying the St. Clair River after its opening to Europeans. Following the War of 1812, transportation along the river changed markedly. (MP)

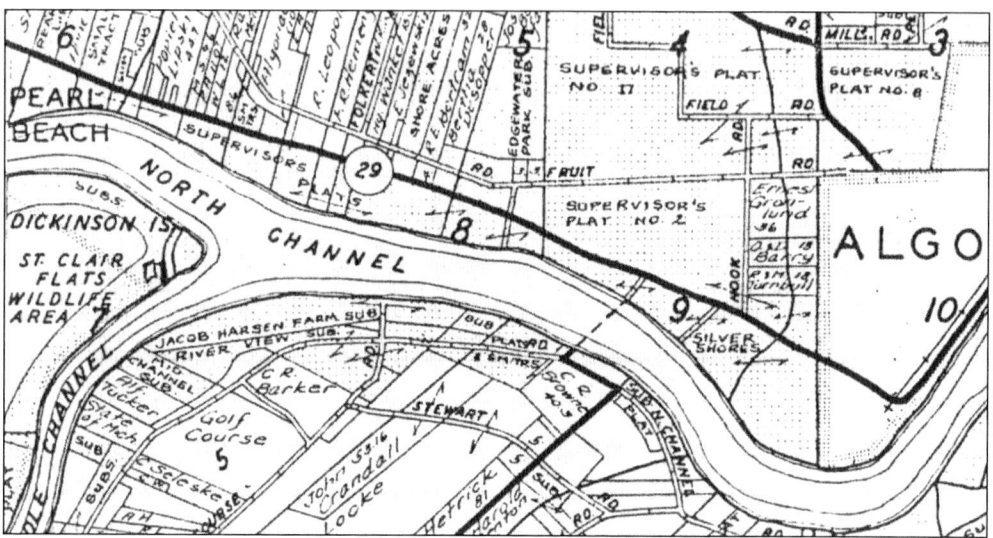

The arrival in Michigan Territory of Americans with their cadastral (north-south-east-west land divisions) clashed with the arpent system of long "ribbon-farm" lots employed by earlier French settlers. This map shows lot lines at the north end of the St. Clair Flats and on the mainland above the North Channel of the St. Clair River, west of Algonac, resulting in crazy-quilt lot shapes continuing to this day. (A.)

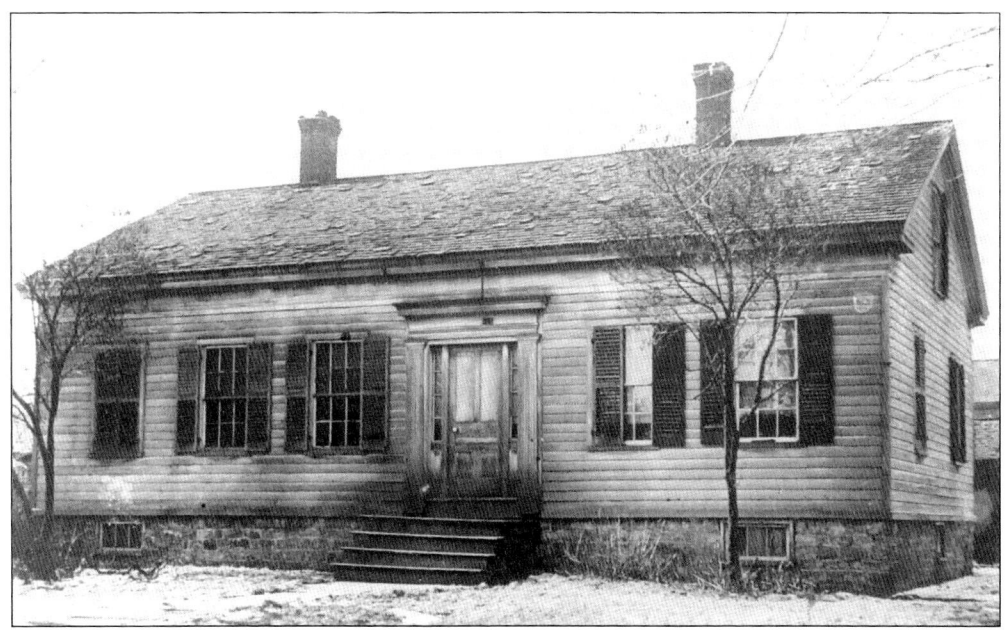

When New Englanders arrived along the St. Clair River in the 1820s, after first living in crude log cabins, they later erected homes more like those they had left behind. This photograph shows a colonial-style house in the Marine City area. Note the classical entrance. As indicated by the two small chimneys, the house had cast-iron stoves, which became common after the 1830s for heating and cooking. (M.)

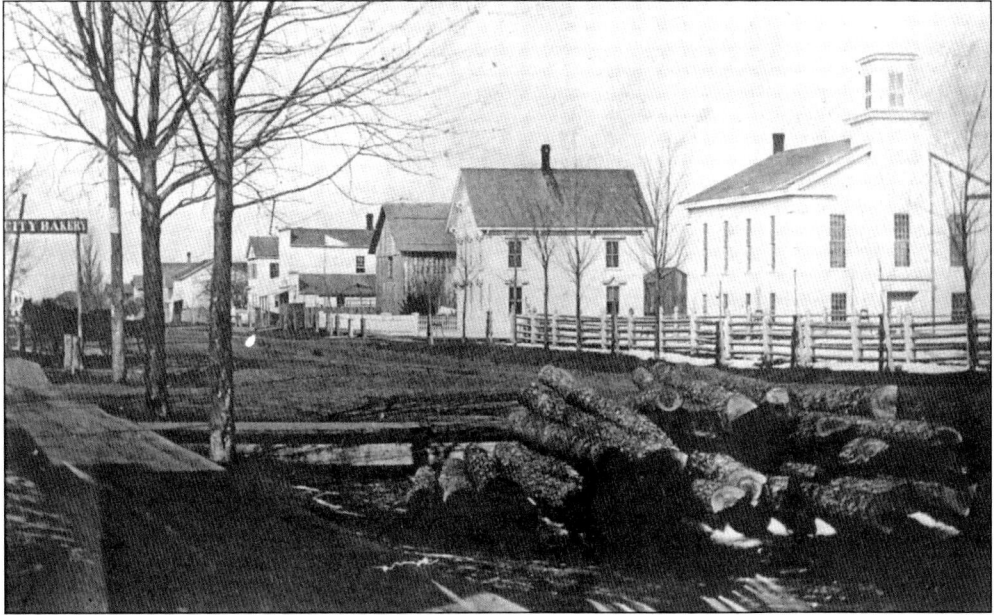

Ample supply of lumber from nearby forests facilitated building New England–like towns along the St. Clair. Settlers were familiar with wood, and possessed or developed the skills to work with it to construct their homes, barns, and commercial buildings. Although this photograph from Marine City is dated 1878, logs are still piled on the streets. The homes, barns, and church could have been lifted right from Vermont. (M.)

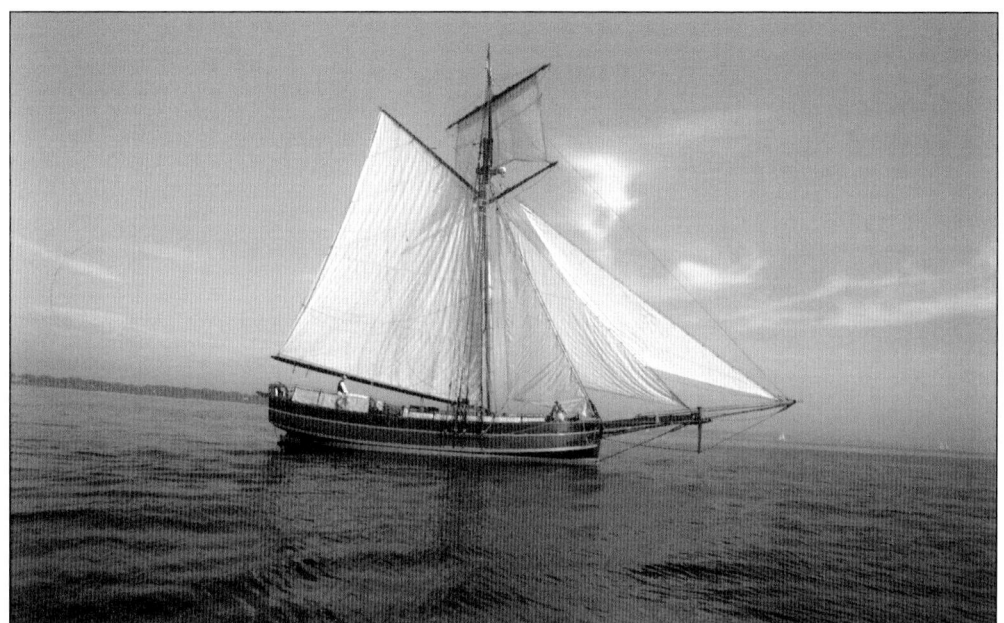

The sheer volume of St. Clair River traffic dictated by the growing 19th-century population and its output of lumber, agricultural, and mineral products pushed canoes to a largely recreational role, replaced by sailing ships such as the *Friends Good Will*. The Michigan Maritime Museum at South Haven operates this authentic reproduction of the original 1810 sailing ship that had an illustrious history in the War of 1812. (MM.)

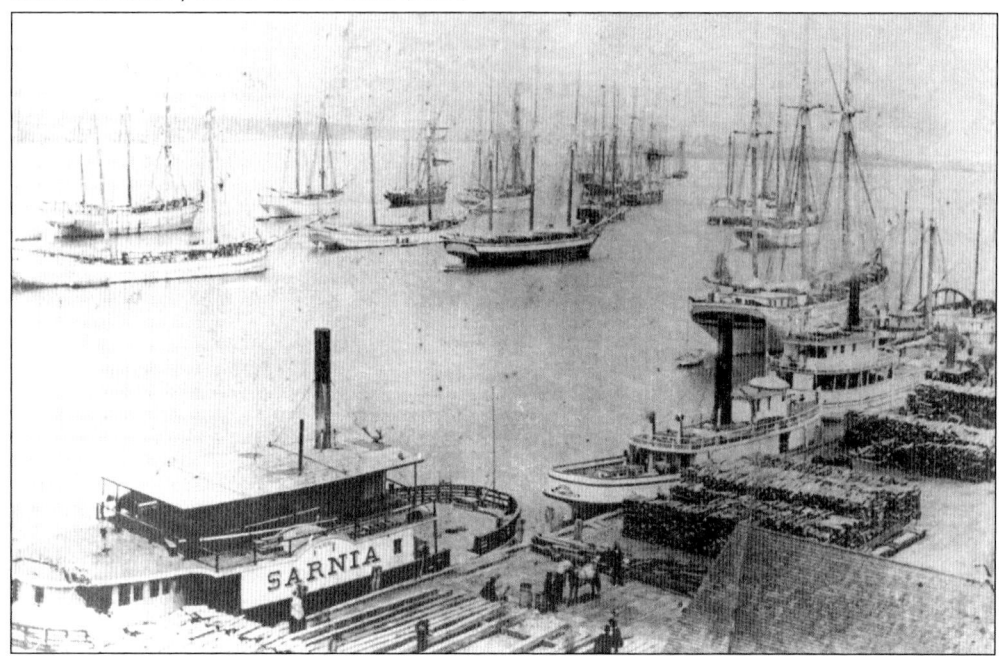

Although steam technology had been introduced in the Great Lakes, it was not until after the Civil War and its technological advances that steamboats began to challenge sails for mastery in the Lakes. This image shows the predominance of sailboats at the Sarnia, Ontario, docks across the St. Clair River from Port Huron. The photograph is dated 1870. (LL.)

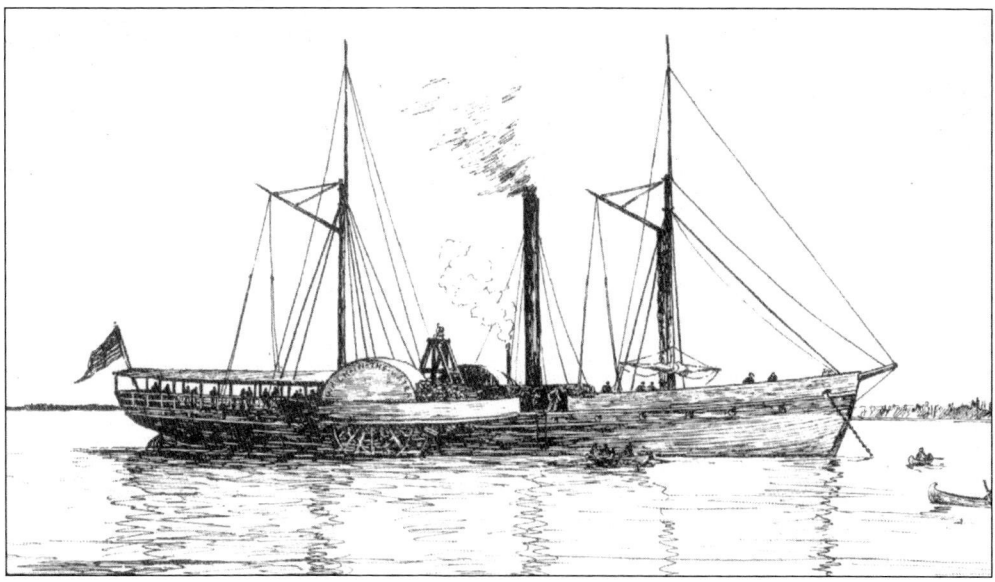

This three-masted schooner is the *J.T. Wing*, the last commercial sailboat on the Great Lakes, shown in protected anchorage off the St. Clair River. After its cargo-carrying years ended in 1936, it served as a training ship for sea scouts, then became part of the Dossin Great Lakes Museum on Detroit's Belle Isle. Rotted away by old age, it was burned on site in 1956 to train fireboat crews. (M.)

This illustration of the first Lakes steamship, *Walk-in-the-Water*, shows it combined the motive power of sail and steam. See also page 17. The use of side paddle wheels rather than stern paddle wheels assisted such vessels in powering over shoals, a common encounter in the Great Lakes, especially in the shallow waters of Lake St. Clair and the Flats at the northern end. (AC.)

23

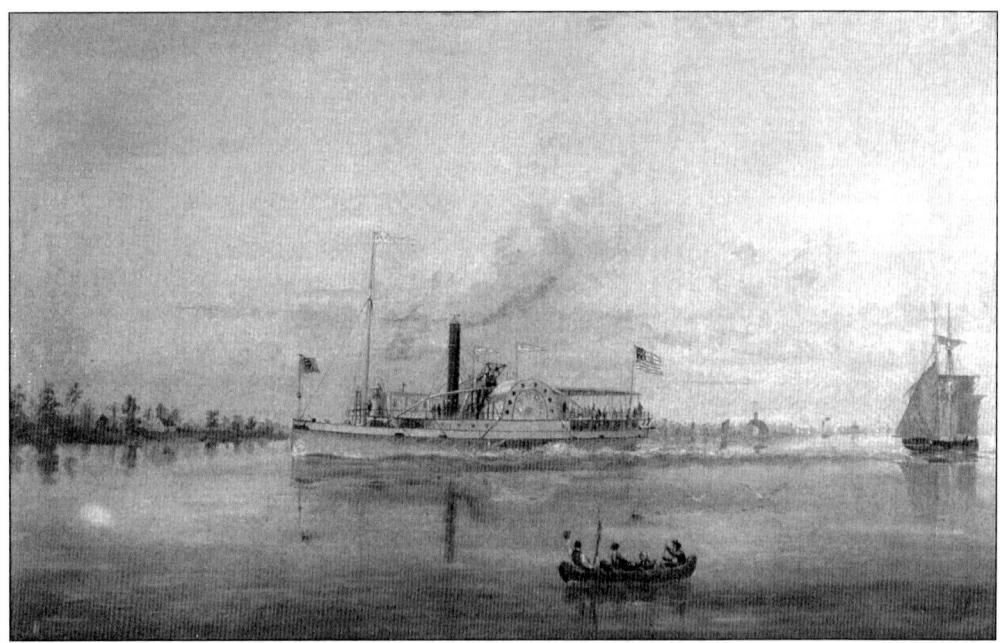

This painting shows a mix of mid-19th-century vessels likely viewed simultaneously on the St. Clair River: the 183-foot side-wheel 1848 steamer *Arrow*, a rowboat, and a sailboat. Steamers primarily carried passengers, who demanded swifter passage through the Lakes than sails could manage. Thus sailing vessels continued mostly to carry supplies and raw materials in the rivers well into the early 20th century. (D.)

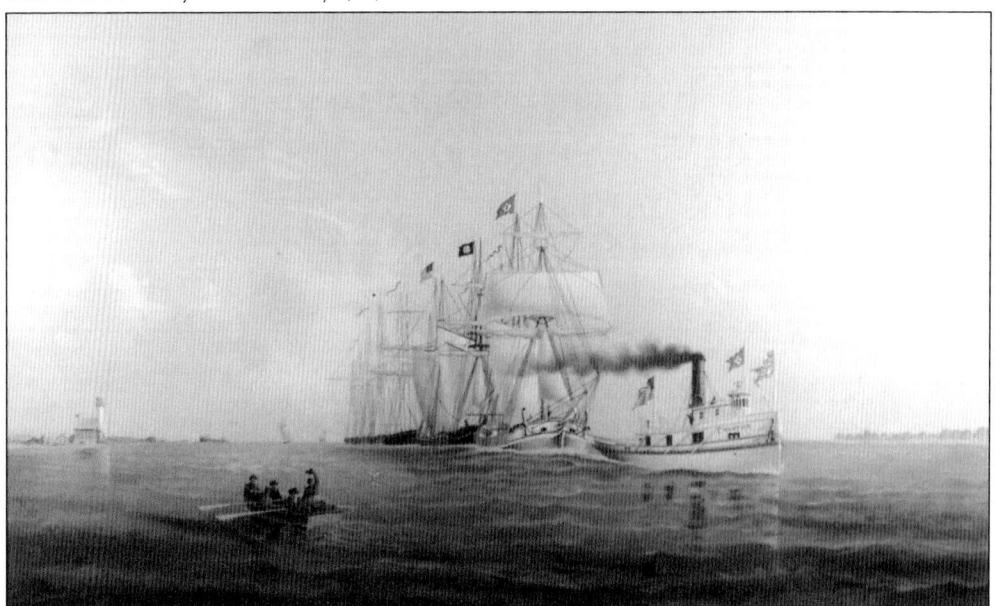

The steam vessel type most commonly seen on Great Lakes waterways in the mid- to late-19th century is typified by the 41-foot 1873 steam-tug *Champion*, here shown towing a row of sailing ships. This combination became particularly important after the 1850s when Lake Superior iron and copper mines began supplying huge volumes of ores to the booming railroad- and steamboat-generated metal industries of Detroit, Toledo, Cleveland, and Buffalo. (D.)

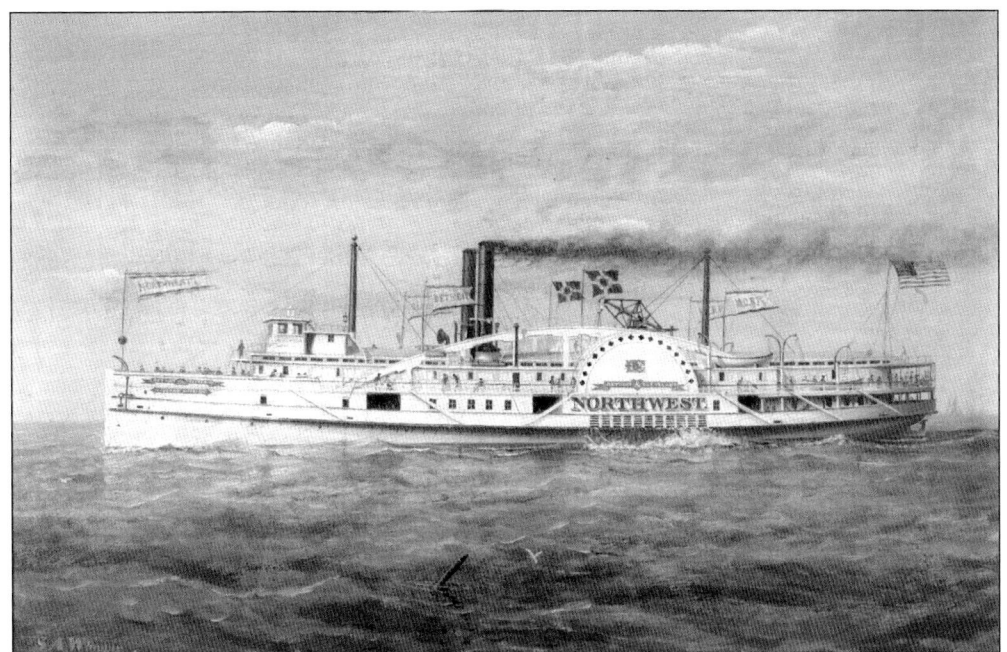

The 236-foot 1867 packet *Northwest* carried both passengers and freight, and was one of the best-known Lakes side-wheel steamers in the late 19th century. Note it has twin stacks compared to the single-stack *Arrow* (previous page), indicating the packet had two engines for greater speed and ability to survive lake storms. On the long rivers of America, steamers were mostly shallow-draft stern-wheelers to facilitate navigation. (D.)

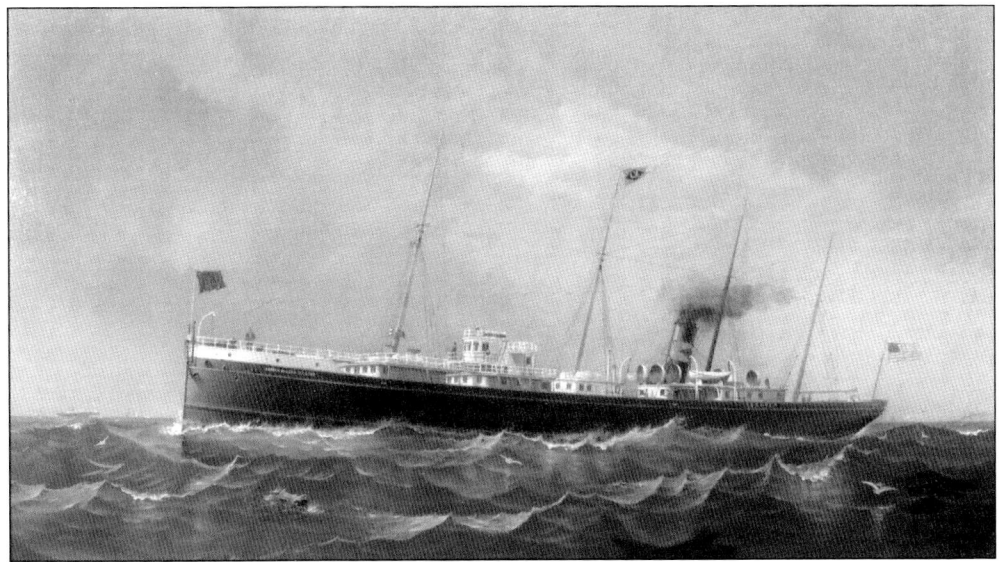

Around the end of the Civil War, the first steel-hulled, screw-driven steamers appeared in the Great Lakes. This is a painting of the steel-hulled 290-foot 1889 package freighter *Seneca*. The technology of steel construction was rapidly advancing but Michigan forests still held ample lumber resources. Steel vessels promised greater protection than wood from fires threatened by the presence of fireboxes under engine boilers, oil lamps, and wood-burning stoves. (D.)

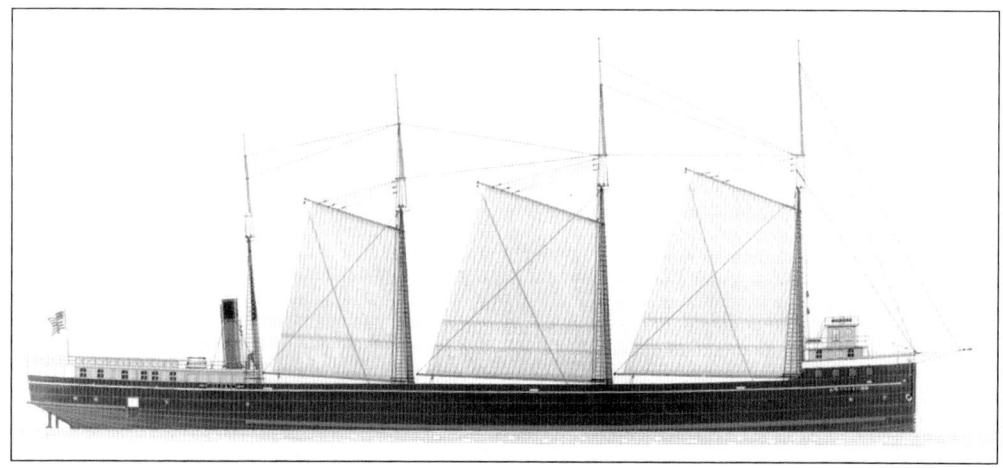

Another solution to the battle between steam and sail was their combination in one vessel, shown in this illustration of the 287-foot 1882 iron-hulled, three-masted *Onoko*. Steam power helped upstream travel against the St. Clair's five-mile-per-hour current from Lake Huron, while sails provided insurance against engine failure. Sailing vessels had to tack to travel upwind, but also did not require frequent re-supply of fuel. (D.)

Traffic on the St. Clair over the last two centuries naturally produced a busy boat- and ship-building industry in every community along the way. Pine River, entering the big river in the village of St. Clair, seems to be little more than a meandering creek, but as shown here in 1887, the 270-foot two-stack steamer *Kaiyuga*, with a wooden hull, was launched on the Pine's south bank. (S.)

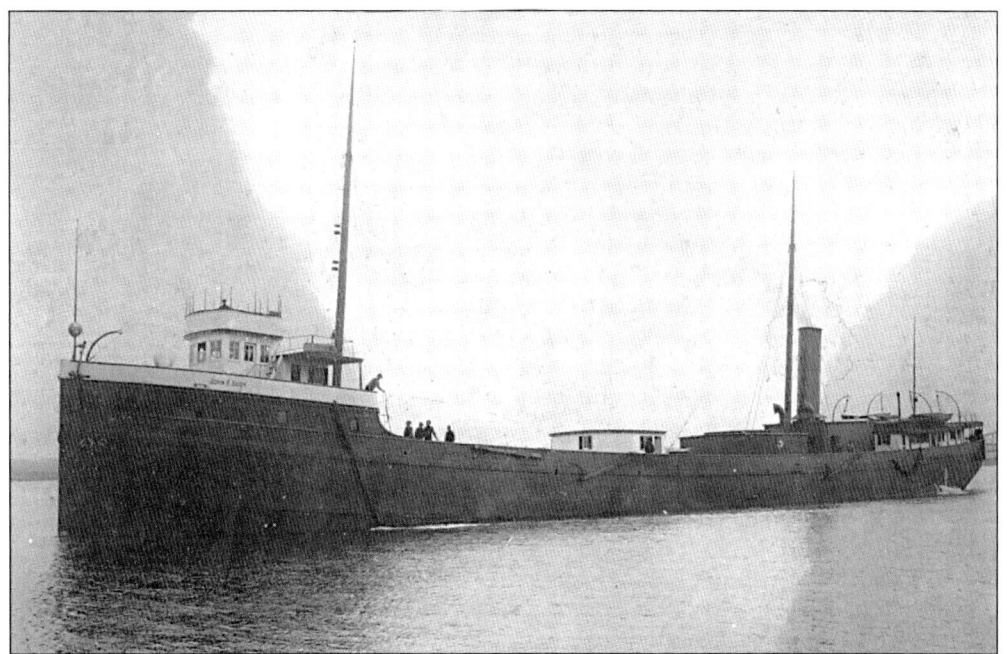

Downstream big industry demands for Great Lakes ships to carry huge quantities led to a new type of ship passing through the St. Clair River by 1900, the bulk carrier. This is the 1886 259-foot wood-hulled bulk carrier *John F. Eddy*, which could efficiently carry loads such as iron and copper ore, coal, limestone, and even grains. (M.)

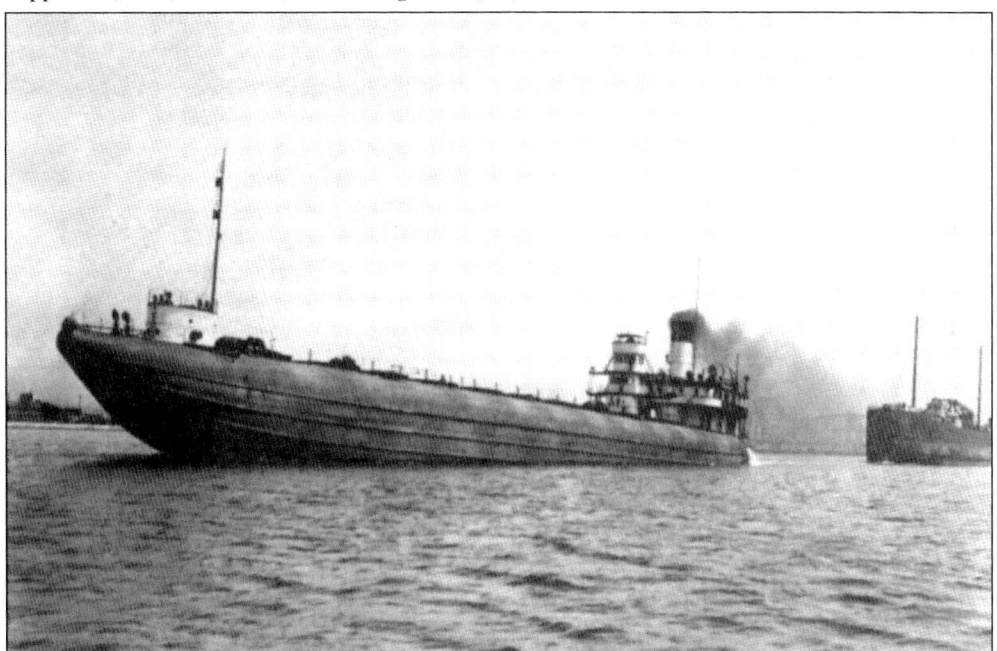

Another unique design seen on the St. Clair River a century ago was the so-called "whaleback," shown here, somewhat resembling a submarine. The rounded hull, however, did not prove to be efficient nor effective in navigating lake storms, so the design disappeared when replacement vessels were built around the time of World War I. (TG.)

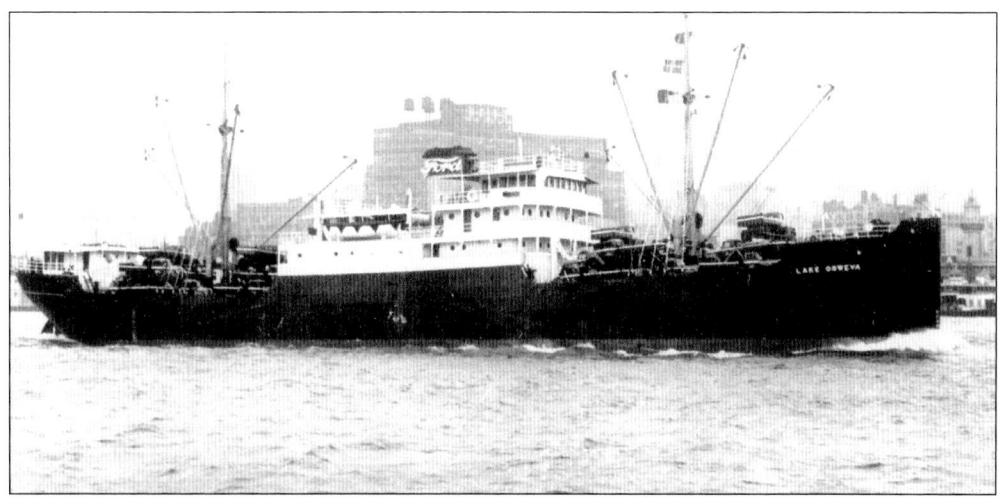

Another freighter type, introduced to the Great Lakes during World War I, was the distinctive center-bridge, center-stack "Laker" like *Lake Osweya* photographed here, possibly in New York harbor around 1939. The US government contracted with Lakes shipbuilders to build these vessels to operate both in lakes and on salt water, with a maximum 261-foot length in order to transit the Welland Canal. *Lake Osweya* was Saginaw River–built. (U.)

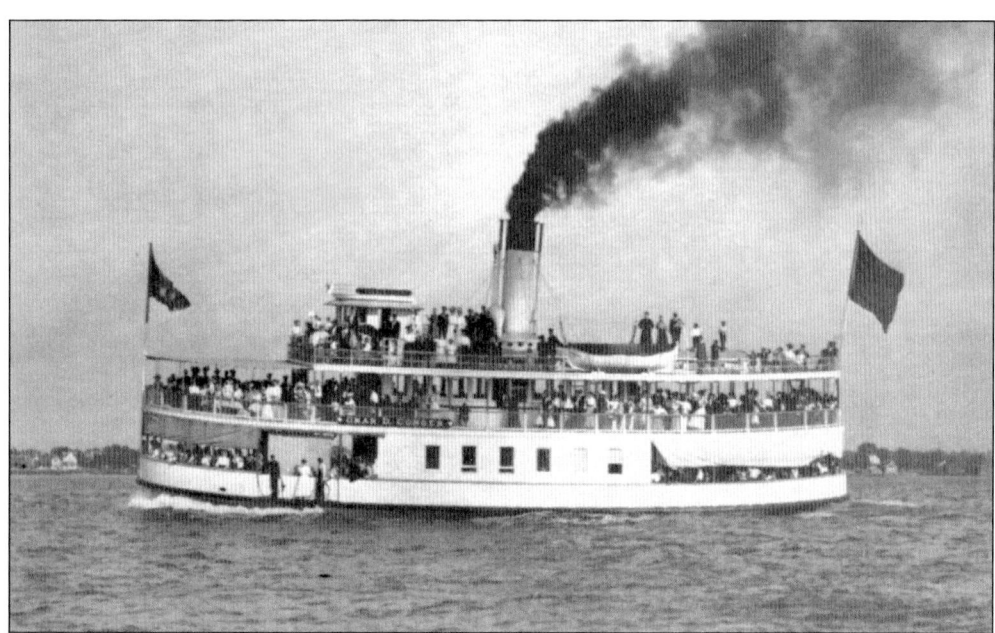

Small ships like the 1882 *Omar D. Conger* plied the St. Clair River carrying passengers from town to town or simply on all-day cruises. Typically, they sailed between Port Huron and Detroit once a day in each direction, stopping to drop off or pick up passengers along the way. The *Conger* ferried between Port Huron and Sarnia, and was destroyed by a boiler explosion in 1922 at Port Huron. (M.)

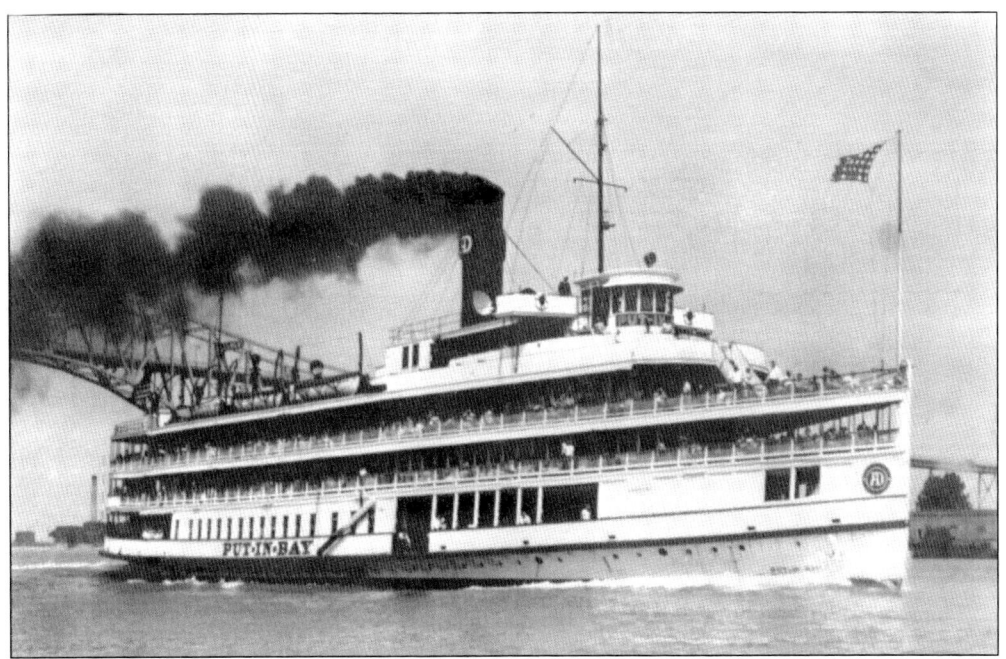

Larger passenger steamers also traveled through the St. Clair River, sailing for longer cruises between major cities on the lakes: Buffalo, Erie, Cleveland, Toledo, Detroit, Port Huron, and points west. This photograph shows the 227-foot 1911 *Put-in-Bay* passing downstream beneath the Blue Water Bridge at Port Huron, indicating it was taken after the bridge's completion in 1939. (M.)

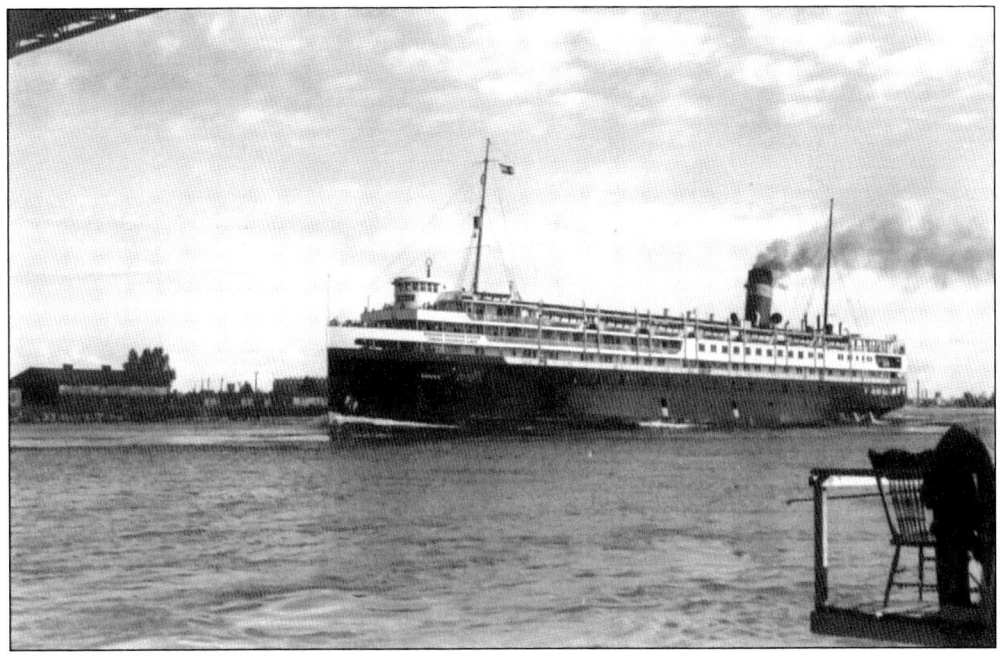

Up until World War II, there was busy competition for passengers on the Great Lakes, with ever faster, more comfortable, and luxurious accommodations such as those offered by the 362-foot *Noronic* (1913), shown as it appears to be upbound in the St. Clair, with Sarnia on the Canadian side in the distance. Compare this to the modern cruise ship *Clelia II* on page 46. (M.)

29

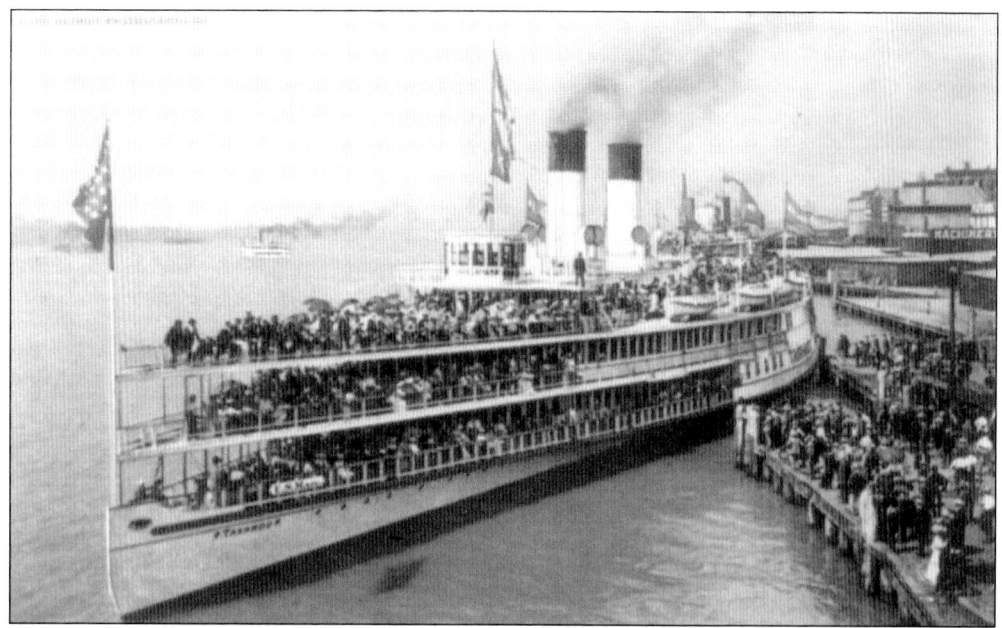

Tashmoo was a 306-foot day cruiser launched in 1900 to serve two island amusement parks, one in the lower Detroit River and the other on Harsens Island in the St. Clair Flats, along with carrying passengers between Toledo, Port Huron, and ports in between. It sank after going aground at Amhurstburg, Ontario, in 1936. This postcard photograph shows a crowd of pleasure seekers aboard the ship as it left Detroit. (M.)

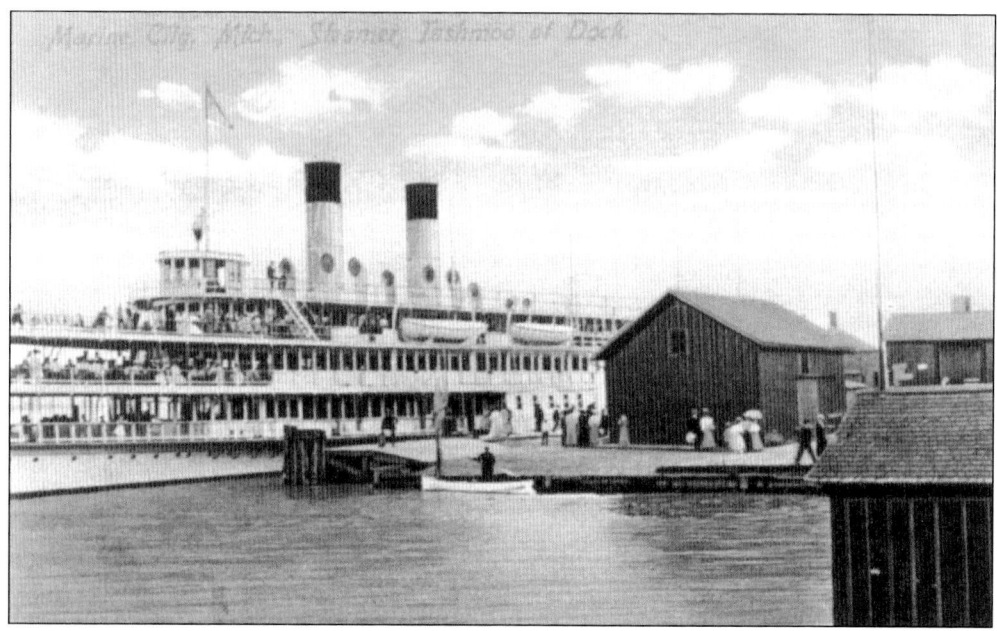

This postcard shows the *Tashmoo* arriving at the Marine City dock several stops north of the ship company's Harsens Island playground. The crowd of passengers has been diminished by those disembarking to spend the day enjoying the pleasures of Harsens Tashmoo Park. (M.)

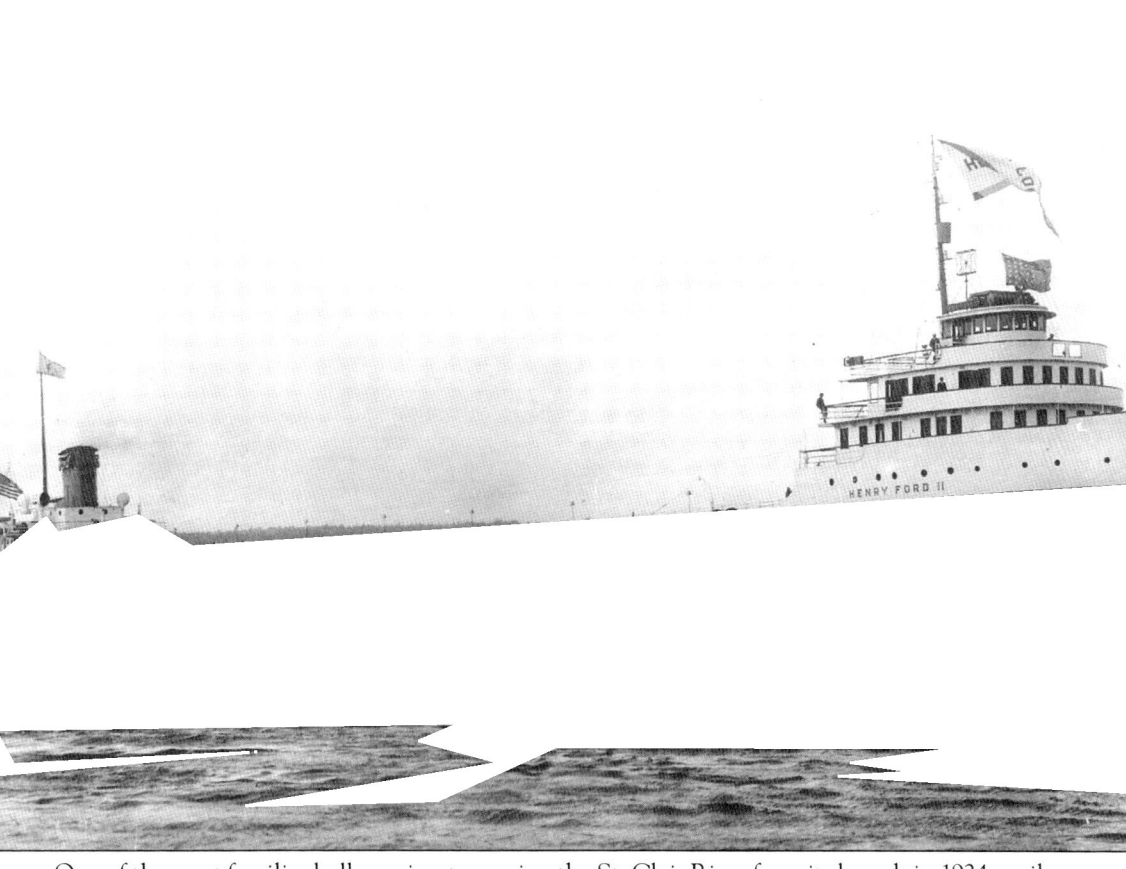

One of the most familiar bulk carriers traversing the St. Clair River from its launch in 1924 until its retirement in the 1980s was the 611-foot MS *Henry Ford II*, used by Ford Motor Company to haul iron ore from Lake Superior to the company's Rouge steel plant in Dearborn. Known simply as "the *Henry*" by its crew, its diesel engines produced a distinctive sound, which riversiders thought sounded like "makin' money, makin' money, makin' money." An almost-identical sister ship was the MS *Benson Ford*. Named after company founder Henry Ford's two oldest grandsons, both vessels were described as Motor Ships (MS) rather than Steam Ships (SS) because of their giant diesel engines. Ford's bulk carriers also carried coal and limestone for the Rouge blast furnaces. (U.)

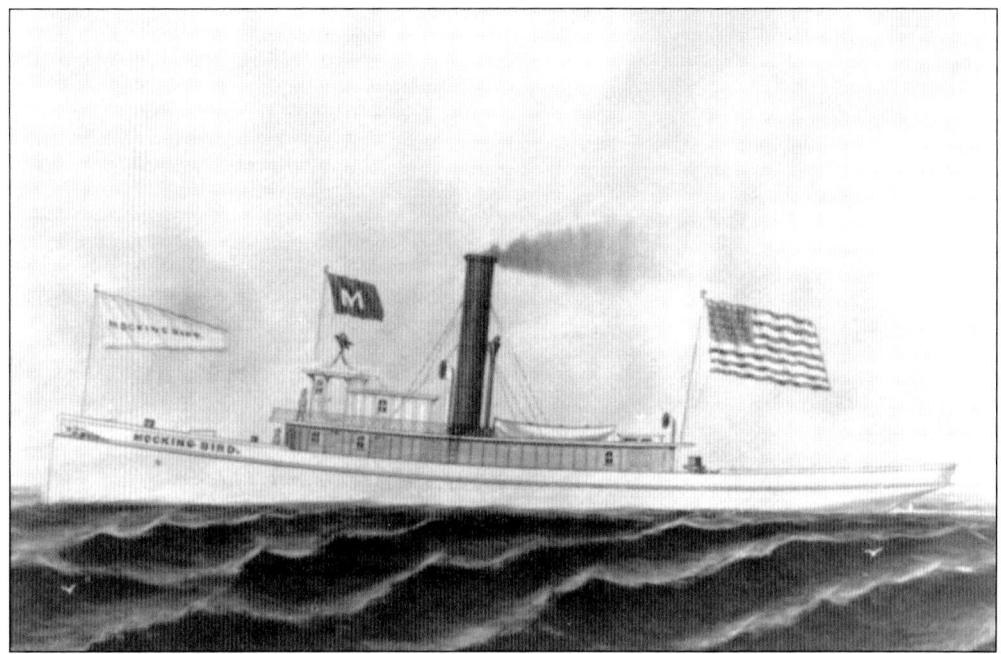

Another vessel commonly seen in the St. Clair River in the late 19th and early 20th centuries was the steam tugboat, also called a barge in the early days. Shown here is the 123-foot 1873 *Mockingbird*, similar to the *Champion* on page 24. Today, tugs are used mainly as utility boats moving barges and helping ships dock in harbors. (TG.)

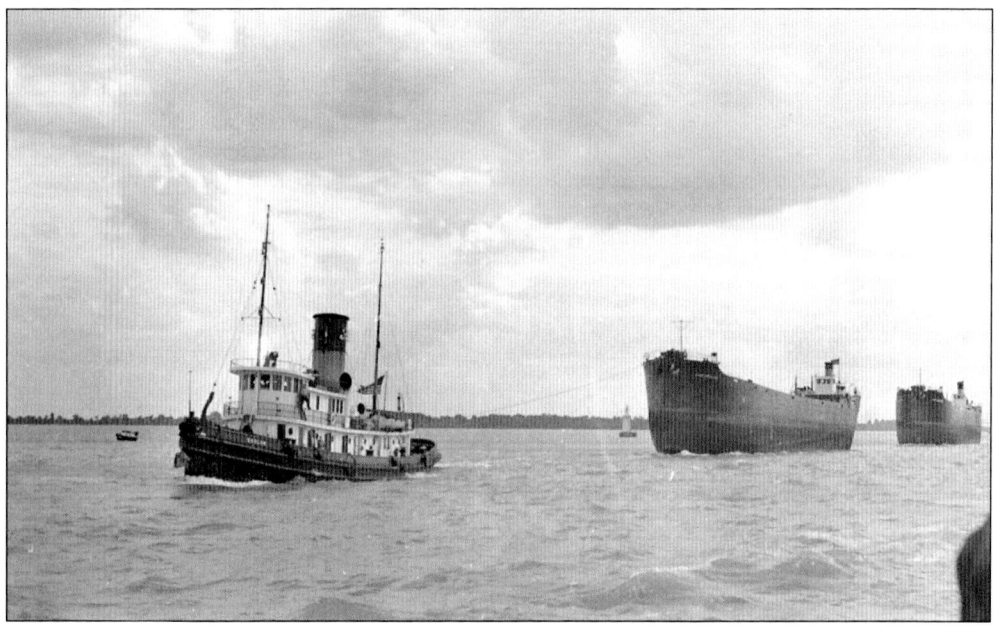

Following World War I, Ford Motor Company bought some 200 surplus freighters and tugs from the US government. Most of the ships were cut up for scrap to feed blast furnaces, but some Laker-type freighters were gutted and used as barges. Here the Ford tug *Barlow* tows two of the ship-based barges. They hauled iron ore and lumber from Lake Superior through the St. Clair River to Ford's Dearborn plant. (TS.)

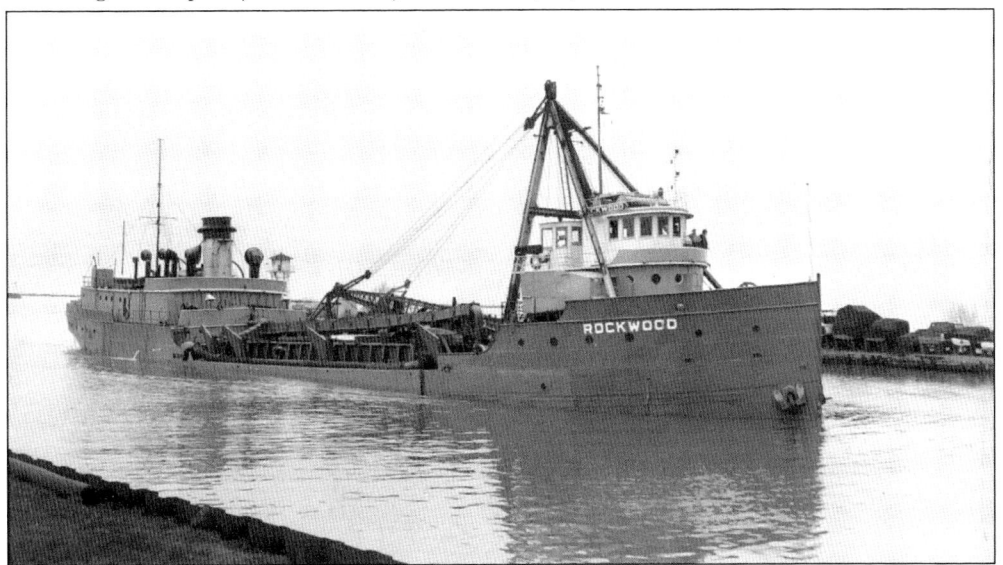

The steam barge *Rand*, shown here, was commonly known as a "lumber hooker" by mariners along the St. Clair River. The 119-foot ship was launched in 1886 and became known for its hooking of stray logs that had fallen into river or lake waters from regular lumber freighters—a sort of legitimate piracy overlooked by authorities. (M.)

Yet another type of utility boat encountered in the St. Clair River was the "sandsucker" dredge like the *Rockwood* shown here. Dredging the river and lake channels has been an important task to insure safe and efficient navigation, as well as providing a reliable source of sand and gravel for building and road construction. (M.)

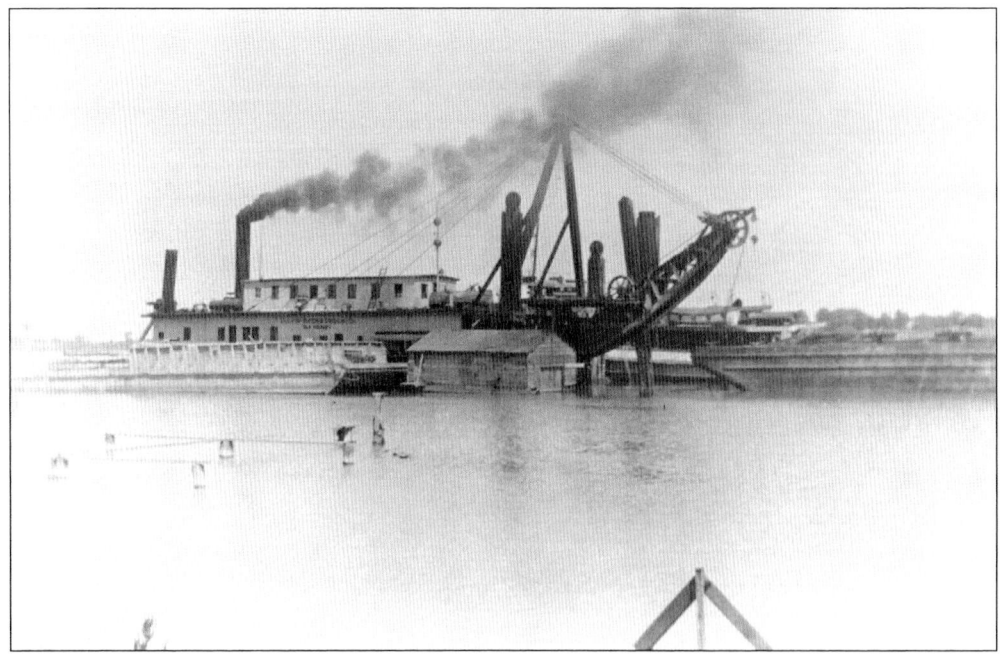

This photograph shows the dredge *Hawthorne* that operated in the upper St. Clair River in the 1930s. It used a steam-powered dragline to scrape the river's bottom, placing the material scraped up onto a nearby barge. Rigs like these are still seen along the river, especially in private dock areas when low water levels prevail. (MV.)

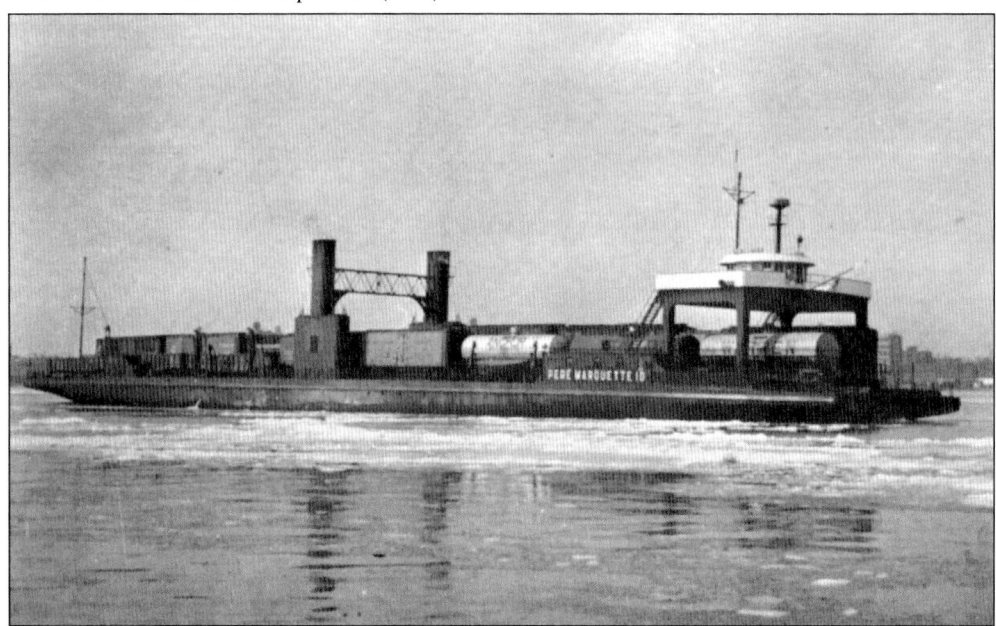

Before the rail tunnel opened beneath the St. Clair River between Port Huron and Sarnia, or to carry excess or dangerous rail cars, railroad ferries like the 338-foot c. 1900 *Pere Marquette 10* were familiar sights on the river. Such vessels also plied the Detroit River between Detroit and Windsor, Ontario and carried rail cars across Lake Michigan and between Michigan's Lower and Upper Peninsulas across the Straits of Mackinaw. (TG.)

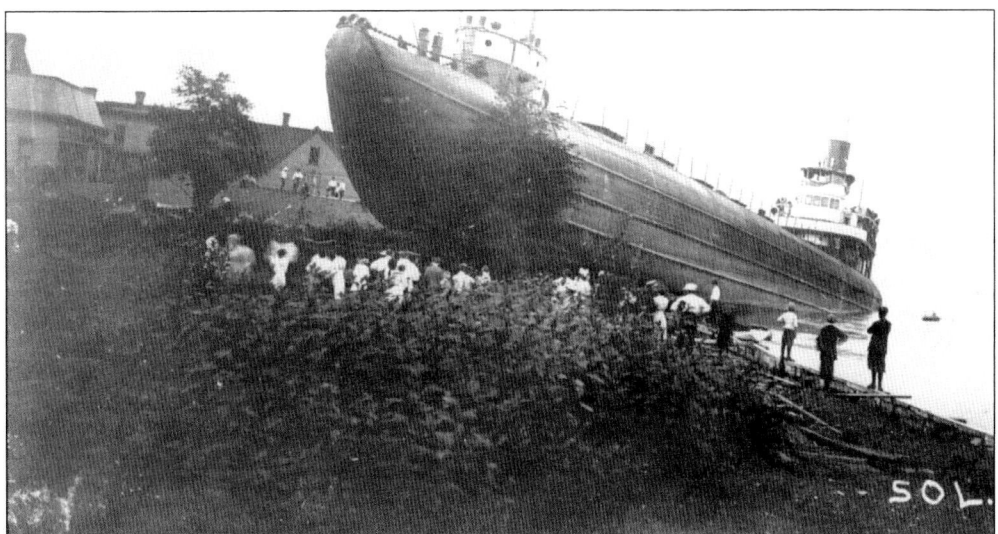

Though much safer today, the lakes and rivers of the Great Lakes system have always been hazardous to navigation. In 1913, the downbound whaleback *Atikokan* lost control and ran ashore at Marine City. In the 19th and early 20th centuries, such accidents were common, along with collisions, groundings, and founderings in lake storms. (M.)

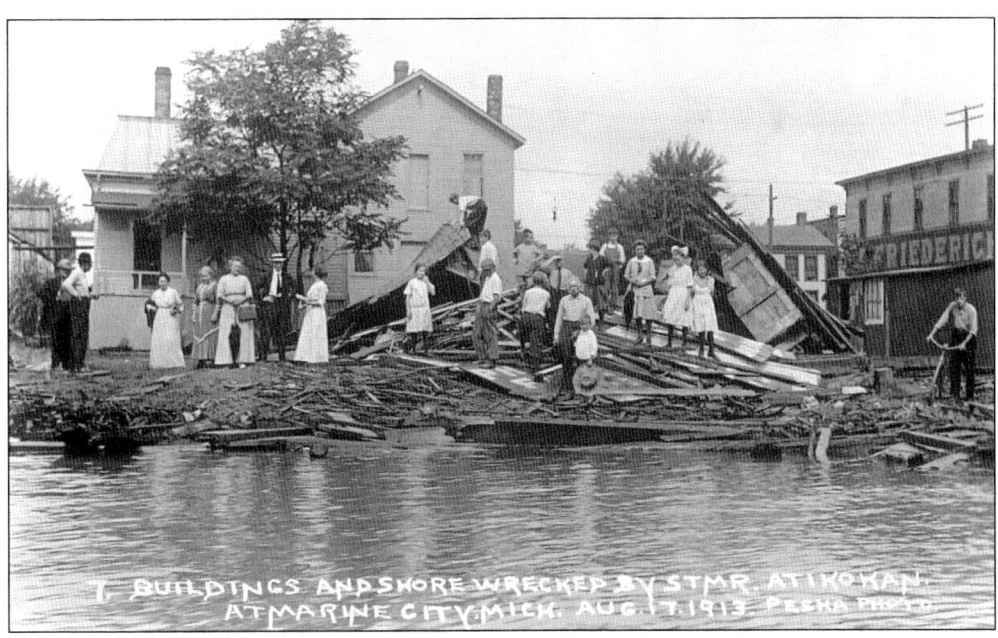

Ashore at Marine City, the out-of-control *Atikokan* demolished riverfront buildings. It was one of the more unusual maritime accidents recorded in river and lake history. In the narrow St. Clair River, the prospect of a freighter losing control or power and blocking the ship channel is always a threat, with the potential for large economic losses when passage is interrupted during the relatively short spring, summer, and fall sailing season. (M.)

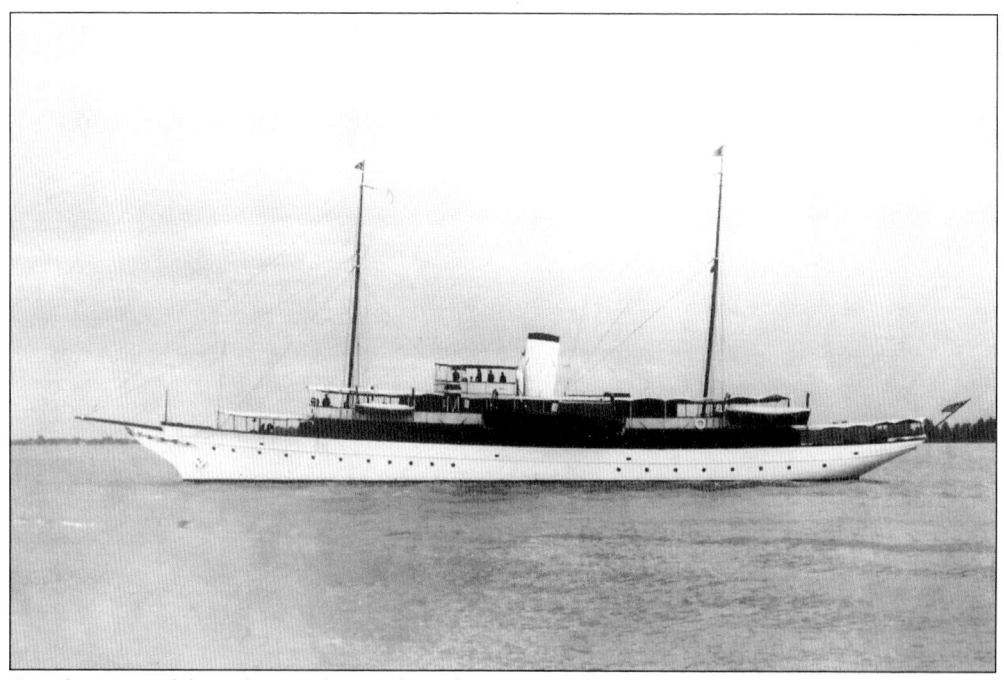

Another type of ship whose sighting pleased visitors and residents alike along the St. Clair River was the millionaire's personal yacht, typified by Henry Ford's *Sialia*. This 201-foot vessel, which Ford bought in 1916, was drafted for US Navy patrol service during World War I and in the 1920s provided a test bed for Ford's experiments with marine diesel engines. (TS.)

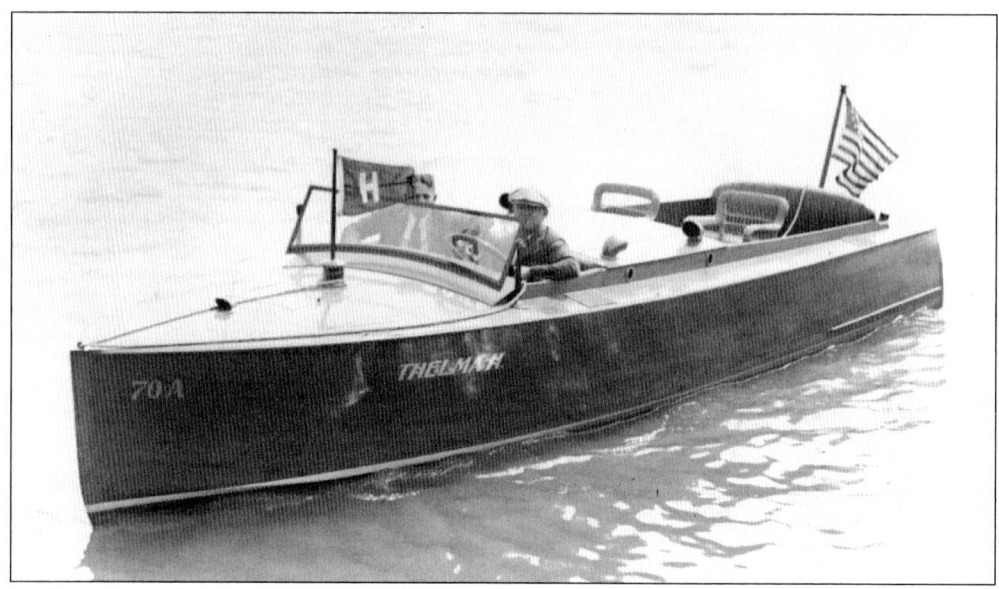

In the 1920s, a huge volume of small boats was introduced to the St. Clair River, the Flats, the rest of America, and indeed the world: speedy wooden-hulled motorboats, especially those manufactured by Chris-Craft in Algonac. This image shows a 1925 model with left-hand steering, possibly for the British market or perhaps because the issue of right- versus left-hand drive for American boats had not been settled yet. (A.)

Prohibition rumrunners were quick to buy the speedy motorboats, especially those designed as utility boats with cargo rather than passenger space. The communities along the St. Clair do not like to talk about their roles during Prohibition today, but this photograph of speedboats used by US Treasury Department agents to intercept rumrunners shows that both sides adopted the new boat type. (M.)

The stock market crash of 1929 put a damper on the pleasure boat market, but motorboat makers such as Chris-Craft, Gar Wood, and Hacker counteracted with promotion of the sporting aspect of their products. This promotional photograph from 1932 shows five Chris-Craft boats of two different configurations speeding through the waters of the St. Clair River. (A.)

One variation of sporting boats in St. Clair waters was the iceboat, a sailboat with runners rather than keel, which took advantage of Michigan's long, cold winters. This image shows eight iceboats lined up, probably in Anchor Bay of Lake St. Clair, west of the Flats and the St. Clair River. (D.)

One type of recreational boat that has stayed constant from the early 19th into the 21st century is the sailboat. This is the *Gertrude*, a 50-foot wood hull yacht built in 1891, which typified the small vessel type providing many years of pleasure use—and probably some utility—on the waters of the Great Lakes. (D.)

38

Three

THE SEAWAY
AND MODERN SHIPPING

As suggested on the opposite page, sailboats are the connecting link between the historical and modern eras of St. Clair River traffic. Power boating in the 1920s and 1930s, rather than detracting from sailing, popularized water recreation. The difference was that commercial freight-carrying sailboats gradually retired in favor of more efficient, reliable, and faster steamships as the 20th century progressed. This sailboat has a fiberglass rather than a wood hull. (M.)

39

In the author's interpretation, World War II marked the end of the historic period in the Great Lakes and the beginning of the modern era. Military boats manufactured under government contracts to St. Clair River boat makers replaced pleasure boats. This is a "picket boat" built by Chris-Craft. Note the weaponless open turret atop its middle. (A.)

This US Army patrol boat was another small wooden military vessel type built for the war effort by Chris-Craft. Generally, Great Lakes boat and ship builders did not fare as well during World War II as did their East, West, and Gulf-coast wooden-boat competitors, such as Higgins. In some circles, the debate continues as to whether the deficit was due to politics or transportation savings from coastal construction. (A.)

Chris-Craft's largest contribution to the war production effort in World War II was high volume construction of landing boats. Here the production of the 8,000th such vessel was marked by signage on the milestone craft, mounted on a truck trailer for shipment to a rail yard, and thence to a coastal port for loading on troop transports to the war zones. (A.)

An example of the many warship types that passed through the St. Clair River during World War II is PC-472, a patrol craft built by the Defoe Shipyards in Bay City, on the opposite side of Michigan's "Thumb" from the river. The vessel would have reached Atlantic waters via Lake Huron, the St. Clair River, Lake Erie, the Welland Canal, Lake Ontario, and the St. Lawrence River. (BC.)

41

In early 1942, America desperately needed to train student Navy pilots to fly from aircraft carriers, but the few carriers in service were fully occupied fighting the war in the Atlantic and Pacific. A quick decision was made to convert two obsolete Great Lakes passenger liners into aircraft carriers. Built in 1924, the 519-foot *Greater Buffalo*, one of the last side-wheelers on the lakes, was one of the two. (AC.)

This is the USS *Sable* after its conversion from the *Greater Buffalo* (above) to an aircraft carrier to train US Navy pilots on the Great Lakes. Both wooden, coal-burning, one-time Lakes passenger ships operated in southern Lake Michigan near a Naval Air Station northwest of Chicago. Here, George H.W. Bush, later the 41st president of the United States, learned carrier landings and takeoffs. Earlier, the carriers passed through the St. Clair River. (AC.)

Following World War II, the US automobile industry experienced a surge in demand for new cars and trucks, which in turn required increased shipment of iron ore from Lake Superior through the St. Clair River. Ford Motor Company added to its fleet of two ore ships from the 1920s by ordering construction of the *William Clay Ford* in 1953. (U.)

Postwar prosperity also rejuvenated the market for large cabin cruisers, such as this 54-foot wooden-hulled yacht offered by Chris-Craft in 1956 for the millionaire class of recreational boater. However, Chris-Craft's traditional inboard wooden-hull boat business was being challenged in the post-war period with outboard motors and steel and fiberglass hulls. (A.)

Opening the St. Lawrence Seaway in 1958 ushered in a new ship era on the St. Clair River: ocean-going "salties," large freighters carrying their cargoes to and from inland Great Lakes ports and the Atlantic Ocean. The Welland Canal connecting the 327-foot elevation difference between Lakes Ontario and Erie was lengthened to 767 feet to accommodate salties. This image shows salty container ship *BBC Mississippi* downbound on the St. Clair River. (DW.)

The demand for more efficient bulk carriers on the Great Lakes led to the launching of several 1,000-footers such as the *American Century* shown here. By comparison, the original *Henry Ford II* of 1924 was a mere 611 feet long, limited by the Soo locks. The additional length permitted larger loads, calling for fewer journeys, but such ships are confined to the upper lakes by the Welland lock length. (DW.)

Installation of a self-unloading structure on an older bulk carrier, such as seen here in the late 1970s on the Ford ship *Henry Ford II*, was another way for an ore shipper to increase efficiency. The self-unloader provided lower labor costs. Ship watchers on the St. Clair shore easily noted such visible changes on familiar ships in the St. Clair. (U.)

Another way to make ships more efficient was to enlarge them. In 1979, Ford took its 1953 bulk-carrier *William Clay Ford*, cut it in half, and had a 120-foot section welded in, lengthening it to 767 feet overall. This photograph shows the new section being floated into place at a Lake Superior shipyard. The lengthening facilitated fewer trips with larger loads, lowering the cost per ton from the Duluth ore docks to Dearborn. (F.)

45

The 643-foot Canadian bulk freighter *Manistee* is shown here using its self-unloader to move sand and gravel from its holds to the Edward C. Levy Company storage lot, located just south of the Belle River outlet to the St. Clair in Marine City. The load probably originated in northern Ohio, destined for building and road construction. (MD.)

In 2009, for the first time in decades, cruise shipping returned to the St. Clair with the 210-foot *Clelia II*. With accommodations for 100 passengers in 50 suites, the vessel is small for a cruise ship; the largest on the high seas is the *Royal Caribbean*, with 2,700 cabins. *Clelia II* makes round trips between Toronto and Duluth during summer and fall months, cruising coastal waters in the winter. (DW.)

At the smaller end of the array of vessels riversiders observe are modern ferries and launches moving among the islands of the St. Clair Flats and the mainland, and crossing the river. Above is the *City of Algonac*, one of the international ferries operating between Walpole Island, Ontario and Algonac, Michigan. Canadian and US customs inspections are required at both ends of the frequent daily crossings of the St. Clair River. Other international ferries operate between Marine City and Ontario, with domestic service (no customs) between a different Algonac dock and Harsens Island. Below is a small passenger launch (no vehicles) servicing Russell Island, located at the north end of the Flats on the US side. No motor vehicles are permitted on Russell except for construction purposes. (MD.)

The streamlined pleasure boat pictured here in the Lake St. Clair ship channel illustrates the revolution in motorboat cabin cruiser design that has taken place in the last 50 years. Gone are the squarish, polished wood hulls and cabins of the past, replaced first by steel and later fiberglass hulls and superstructures. (MD.)

In place of the mahogany-hulled speedboats used by Treasury agents during Prohibition to chase rumrunners (page 37), today's Immigration and Customs officers of the Department of Homeland Security use outboard-powered inflatable boats like this to patrol the St. Clair River. Their main objective is to intercept illegal immigrants rather than smuggled booze. (MD.)

48

Moving buildings via barges over the waterways was an old practice along the St. Clair and on the Flats. It continues today, as shown by this photograph of a two-story house downbound on the river. Transporting buildings over water is a lot easier than over land, where streets have to be blocked and utility wires raised or disconnected. (DW.)

As this photograph suggests, motor sailboats have taken the place of yachts for extended vacations on the water. This motor sailor was downbound through the St. Clair Ship Channel on its way to an extended cruise before Michigan's winter weather set in. If headed for Florida, the Bahamas, or the Caribbean, it would have to pass through the NY Barge Canal or Canada's Welland before reaching the Atlantic. (MD.)

This photograph of the *Murray Bay* stuck in ice at Roberts Landing between Marine City and Algonac in April 1984 demonstrates one of the most common navigational hazards in the narrow, twisting St. Clair River. The 730-foot bulk carrier had made the downbound journey, presumably from the west end of Lake Superior, without a problem but the ice in the half-mile-wide river piled up to block passage. (M.)

Coast Guard icebreakers are called upon to rescue ships caught in St. Clair River or lake ice, and to keep navigational channels open. Ice can unexpectedly accumulate, especially when ship operators push the navigation season with winter passages. Here two Coast Guard cutters in Operation Coal Shovel clear the way for a downbound ore carrier to cross Lake St. Clair in January 2010. (USCG.)

Four
FRUITS OF LAND AND WATER

Iron traps in the 18th century revolutionized the harvesting of beaver pelts. Before this, Native Americans stalked beavers by clubbing them outside their lodges. With an iron trap staked to the waterway bottom outside a beaver lodge, the animal was pinned underwater where it drowned, permitting pelts to be harvested more or less at leisure. Beaver pelts remained a leading fruit of the St. Clair River region's land and water well into the 19th century. (E.)

Hunting has been a necessity for food, a popular recreational pastime, and, still for some, an occupation throughout the more than four centuries since Europeans arrived in the St. Clair region. In this undated 19th or early 20th-century image, duck hunters are proudly displaying their harvest of the winged fruits of the region. (A.)

Before settlers flooding in from the East in the second quarter of the 19th century could establish their farms, the forests of Michigan's Thumb area west of the St. Clair River had to be harvested. This image shows the wealth of native pine that was the area's prime natural resource before the forest was clear-cut and the lumber processed for the houses of Detroit and elsewhere downstream. (P.)

Harvesting Michigan's forests in the 19th century became a major source of employment and, for a few fortunate investors, a source of great wealth. The image at the top shows how cut-and-trimmed tree logs in St. Clair County were loaded onto animal-drawn skids for transport to a temporary railhead in the forest or to a convenient river for floating downstream. The bottom photograph, taken at Port Huron in April 1904, shows how logs from upstream lumbering filled the Black River to the point where navigation was impeded. But once the nearby forests were clear-cut, the lumber industry simply moved further north and west in Michigan. (P.)

From St. Clair's virgin forests, the harvest would make its way by rail or river to steam-powered saw mills on the big river where it would be transformed into dimension lumber and handily loaded onto sailboat freighters bound for growing urban markets such as Detroit and Toledo. This image shows the work crew of the Upper Saw Mill at Marysville, south of Port Huron. (MV.)

Saw mills along the St. Clair River also provided lumber for the towns growing up along the waterway in the 19th century. Horse- or mule-drawn wagons like these transported the lumber to building sites close by, a process provided by lumber trucks in modern times. These lumber wagons are from the Howard sawmill, probably located in Port Huron. (P.)

Tashmoo Park
Little Farms

Tashmoo Park Little Farms
Are Adapted to The Growing of Fruit

The average fruit farm is worth $500.00 per acre, and costs very little to establish.

POULTRY

Average hens earn a profit of $1.25 to $2.00 per year. The prize breeds earning from $5.00 to $8.00 per year.

TRUCK GARDENING

Your market is Detroit, Port Huron and Algonac, and everything you raise can be sold to the resorters of Harsen's Island and the St. Clair Flats.

A PLACE OF PLEASURE

Hunting, Fishing, Bathing, Boating, and in fact any kind of recreation is possible within five minutes walk from the farm sites.

PRICE AND TERMS

Cannot be equaled within 50 miles of Detroit in any direction.

Call
Campbell & Harding
— HICKORY 0051 —

As the forests of St. Clair County became cleared, farming beyond mere subsistence could be established. This is a turn-of-the-century advertisement for farmland placed by a land development operation of the Tashmoo company, which operated day-cruise steamers and amusement parks in the waterways between Toledo and Port Huron in the early 20th century. (A.)

In this undated 19th-century photograph, Michigan farm buildings and animals are shown against the backdrop of a river, possibly the St. Clair. The first French farms in the region were deep, narrow "arpent" lots with the farmhouse, likely a log cabin, near the watery highway of the river, with a vegetable garden close behind, then an orchard, pastureland, and—furthest from the river—a wood lot. (B.)

Dairy farming to provide milk for the growing city of Detroit, some 60 miles away, has been a continuing source of income for St. Clair County farmers since the mid-19th century. Here a milkmaid poses holding a container of fresh milk, while a youngster stands behind the dairy cow. Until the coming of the railroad and the light rail interurban, dairy products traveled to the market by boat. (B.)

If a St. Clair County farmer had to use the waterways as the only means of getting his products to the market downstream in Detroit, it was handy to have a barn/warehouse and docks right on the water, as shown in this 19th-century photograph. In addition to dairy products, riverside farmers counted on revenue from fresh garden vegetables, grains, and, for the thousands of horses in Michigan's largest city, hay. (B.)

A typical 19th-century Michigan farm family is shown in this photograph, with the farmer and his horse and wagon (the pickup truck of the time) at left, family and perhaps hired hands in center, and a cornfield in the distance. A barn, perhaps a stable, is attached to the residence. Note the hand-operated cast-iron water pump, which could raise water from as much as 23 feet down. (B.)

57

In the villages of the St. Clair riverside as elsewhere in America, residents typically enjoyed flower and vegetable gardens in their back yards, such as in this Algonac homestead. The river can be seen at the end of the side street. These gardens were harvested for personal use or, at the most, gift or sale to neighbors. (A.)

Large-scale investor farming created a new industry in Michigan's Thumb area late in the 19th century. Here is a huge brick sugar-beet processing plant in the Marine City area. Sugar beets, which resemble red beets except for their whitish color, remain today a major source of domestic household sugar, and the Thumb is one of America's largest sources for refined sugar-beet sugar. (M.)

Processing chicory into coffee substitute was another industrialized agricultural industry in St. Clair County, as shown by this Port Huron chicory factory. Chicory is a scraggly roadside weed that grows up to a yard high with blue, violet, or white flowers. Grown commercially, its roots can be baked, ground, and roasted into palatable coffee or mixed into coffee made from tropical beans. Its leaves are also used as salad ingredients. (P.)

St. Clair County's glacial- and flood-deposited soil was good for lumbering and agriculture and also held useful clay beneath the sod. Here a 19th-century Marine City operation excavates clay for the local brick-making plant. Bricks were commonly used locally for commercial and industrial buildings rather than residences. They could also be shipped by boat to Detroit and other waterway cities. (M.)

In 1882, salt deposits were discovered 1,600 feet beneath the river's edges near Marine City. A derrick like that seen at right center of this photograph of Marine City's Belle River was the sign of a salt extraction process. Local salt companies gave way to major international salt companies. Salt was removed by forcing hot water down the well, pumping out the saline mixture, and boiling it into commercial table salt. (M.)

The land deeper beneath the soil of St. Clair County is also rich in oil and gas deposits, though generally not in commercially feasible amounts for extraction. Still, many farms in the area have their own small-scale wells and storage facilities. This image shows an oil well pump alongside a Cottrellville Township dairy barn, just a few hundred feet from the river. (DW.)

Five

VACATIONERS, COTTAGES, AND HOMES

This 1895 map of hotels and clubs on the St. Clair Flats in the St. Clair River delta of northern Lake St. Clair shows that the vacationland area was already well developed at that time, with numerous resort and recreational facilities to attract wealthy and upper-middle-class patrons. These mostly large, multistory frame buildings were erected on tiny spits of low-lying islands, reachable then only by water. (A.)

This image from a turn-of-the-century color postcard shows a crowd of mostly young people at the dock of Camp Algonac on Russell Island, a private resort operated only from 1905 to 1910 with facilities mostly under tents. Note the covered steam launch on which they have arrived for a week's outdoor recreational vacation. (A.)

Here another c. 1907 postcard shows the Camp Algonac "tent city" where vacationers slept, ate, and played indoor games should the weather prove inclement. Among the outdoor recreation options available were sailing (foreground), rowing, canoeing, and swimming. For many guests it was a welcome relief from crowded urban lifestyles. (A.)

This postcard illustrates the scope of Camp Algonac's tent city, with 10-by-12-foot sleeping tents in the foreground and larger communal tents for dining, concerts, dancing, and games in the rear. Guests traveled hundreds of miles on railroad excursion cars to Detroit, where they transferred to steamboats to reach Russell Island on the St. Clair River. (A.)

Camp Algonac's sandy beach, beach cabanas, and rowing skiffs are pictured here. Despite the unsophisticated accommodations of tent living, for working- and middle-class folks from all over the Midwest, the resort offered a relatively inexpensive Mecca, especially compared to the huge resort hotels only a canoe-paddle downstream. Nonetheless, Camp Algonac closed in 1910, and Russell Island later was platted for lot sales. (A.)

The cover of the *White Star* promotional magazine (left) probably dates from 1910 to 1915, judging by the speedboat in the foreground. Vacationers arrived at Detroit railroad stations, from which multi-decked excursion steamers like that shown whisked them to St. Clair Flats resort hotels, clubs, and camps. Below is a typical schedule for White Star Lines from the same era. It shows that the 60-mile Toledo-Detroit voyage took nearly five hours, including a stop at an amusement park on Sugar Island in the lower Detroit River. The longer Detroit–Port Huron leg took five to six hours with as many as 18 brief resort stops along the way. During the busy summers, there were two sailings in each direction every day but Sunday. (MMD.)

This color postcard shows the Tashmoo Park Landing for the Harsens Island amusement park owned by the Tashmoo Company, another resort steamship line that owned and operated this park for day-trippers. There were no overnight facilities for visitors at Tashmoo Park. The *Tashmoo* side-wheeler excursion steamboat is pictured on page 30. (A.)

Ashore at Tashmoo Park was a huge dance pavilion, illustrated here in another c. 1910 color postcard. Today, the only remnant of once-joyous Tashmoo Park is the old pavilion—but now the sweeping roof covers a facility for boat repair and storage as part of a large marina on Harsens Island. (A.)

This postcard shows the turn-of-the-century bathhouse for swimmers at Tashmoo Park. Here, day-trippers could change into bathing suits to enjoy cool swims in the passing St. Clair River, sun themselves on the grassy lawn, or socialize on the bathhouse deck, enjoying the cool breezes off the river on a hot summer day. (A.)

This 100-year-old postcard shows there is nothing new about tourist traps. Visitors to Tashmoo Park flocked to "Indian" souvenir stands to shop for memorabilia from their day trip to the amusement park. For urban Eastern and Midwestern Americans of the day, "real" Native American culture remained an exotic source of wonder. Canadian First Nations people, from the same tribes as once occupied the U.S. side, lived on a reservation on Walpole Island across the St. Clair River. (A.)

The Star Island Casino was another attraction for day-trippers or vacationing sports from nearby resort hotels. Shown here on a vintage postcard, the huge casino is mounted on stilts in the St. Clair River, with its own extensive docks to receive visitors. Besides offering entertainment, the casino and other resort facilities provided job opportunities for local area people. (A.)

The Old Club, a very private watering hole at the southernmost point of the St. Clair Flats frequented primarily by wealthy Detroiters, is illustrated on this c. 1910 color postcard. The club grounds included a nine-hole golf course and many vacation cottages mounted on stilts. Like many other structures on the Flats, this original building was later destroyed by fire. Today's clubhouse is much more modest. (A.)

Typical of small resort hotels in the Flats was The Damer, shown on this turn-of-the-century postcard. Stilts seem to support the hotel over the low-lying island, surrounded by canals with small boat docks. Hotels in the Flats, whether large or small, catered to well-off families who stayed for days, weeks, and months—even the whole summer. In hunting season, most of the guests were men. (A.)

In contrast to the tiny, home-like Damer above, the multistory, 150-room Grande Pointe Hotel, shown on this postcard, was huge. It stood at the north end of Harsens Island on the South Channel of the St. Clair River. Note the recreational sailboats beside the dock. The Grande Pointe offered its guests an elaborate dining room and luxurious rooms. (A.)

The Marshland Hotel in the Flats, pictured on this postcard, stood in size between the small Damer and the huge Grande Pointe. It was located near the middle of the South Channel "hotel row" of the St. Clair River's delta. Almost all the Flats hotels eventually succumbed to fires started by the kerosene lanterns and wood stoves of the time. Firefighters were far away in both time and distance. (A.)

The Rushmere Hotel, shown on this postcard, featured many associated outbuildings. Notable among them is the large windmill at the left of the main building. The windmill, as on many farms of the period, was used to pump water, whether from below ground or the river. The Rushmere was located toward the southern end of the St. Clair River South Channel. (A.)

The Riverside Hotel, shown on this turn-of-the-century postcard, was located on the next island north from the Marshland, near the center of the South Channel's hotel row. Later known as the Idle Hour Hotel and Idle Hour Club, as shown on page 121, today it is the only survivor of all the grand c. 1900 resort hotels. (A.)

This 1985 navigation chart shows how the Venice of America, once the site of a late-19th-century resort hotel row, appears today with a state highway connecting most of the small islands, which in turn are surrounded by canals. The layout is ideal for either year-round homes or summer cottages, with accommodations for the powerboats much favored by retired or commuter residents, weekenders, and vacationers. (NOAA.)

THE OAKLAND
ST CLAIR 2338
PESHA PHOTO

Twenty-odd miles north of the St. Clair Flats lies the river town of St. Clair. Two large resort hotels were built here at the end of the 19th century. As shown in this vintage photograph, the more elaborate of the two St. Clair hotels was the six-level, 235-foot wide Oakland Hotel, sited south of the Pine River near the present-day Cargill Diamond Crystal Salt works. (TG.)

On the north side of where the Pine River enters the St. Clair River in the town of St. Clair was the more modest four-level Somerville Hotel, shown in this postcard view, originally a school for young women. Uniformed cadets posing on the lawn suggest the photograph was taken around the time of the Spanish-American War in 1898. Today the area is a public park on the riverfront. (TG.)

71

FOR SALE

MODERN SUMMER HOMES

Cottages To Rent for Season

SUNSHADE, SANS SOUCI VILLAS

SANS SOUCI VILLAS
850 Feet Frontage on South Channel
HARSENS ISLAND, ST. CLAIR FLATS

Two hours ride by Star Line Boats from Detroit, Mich. Each house has 6 Bedrooms Furnished, Screened Porches, Running Water, Detached Bamboo Dining Room—Good investment for two or three families—Purchase price about one-half its value, terms reasonable.

Write for full particulars and Colored Photos of Villas to

CHAS. THURMAN, Agent 418 FORD BLDG. DETROIT, MICH.

Around the time of World War I, prosperity changed the focus of the Flats from resort hotels to summer cottages. This is a newspaper advertisement for a cottage real estate development, Sans Souci Villas, on Harsens Island. The house design shown is typical of those popular around 1912. The advertisements probably ran in cities connected to Detroit by railroad and interurban lines, such as Pontiac, Flint, Ann Arbor, Jackson, Lansing, Kalamazoo, and Grand Rapids in Michigan, and further points such as Toledo, Cleveland, Columbus, Cincinnati, Pittsburgh, South Bend, Indianapolis, and Louisville to the south. Excursion trains brought working-class tourists to Camp Algonac on Russell Island from as far away as Terre Haute, Indiana, around 1905. Both rentals and sales are advertised. (A.)

This is a 1902 color postcard showing houses on stilts—summer cottages—along the South Channel of the St. Clair River in the Flats. In the distance is one of the resort hotels—possibly the still-standing Riverside/Idle Hour—with its three towers (see page 70). Each two-level cottage features a deep wraparound porch and a dock. (A.)

This contemporary photograph of the canals, boats, and summer cottages along the South Channel shows why the Flats area was so readily labeled the "Venice of America." Among the boats tied up along the canal are a jet ski, a pontoon boat, an outboard-powered fiberglass-hull fishing boat, and an outboard skiff—all boat types unknown to the area until after World War II. (MD.)

Many summer cottages erected between 1910 and 1930 in the Flats and in communities along the St. Clair River were kit houses ordered from catalogues such as Aladdin, Sears Roebuck, and Montgomery Ward. This is a typical bungalow from the 1914 Aladdin catalogue. The Aladdin company was based in Bay City, on the other side of Michigan's Thumb from the St. Clair River. (MD.)

The resort community of Cherry Beach between Algonac and Marine City on the St. Clair was established before World War I. Many of the well kept, mostly year-round homes in Cherry Beach, as shown in this contemporary photograph, appear to be kit houses, based on their small footprint and architectural styles. (MD.)

This photograph shows a typical summer cottage of bungalow design on Russell Island. Like those in Cherry Beach, it has an appearance and modest size suggesting it could have been a kit house. No motor vehicles are permitted on the private, property-owner-corporation island immediately across the North Channel of the St. Clair River from Algonac's commercial district, ferry dock, and riverfront park. (MD.)

A far more elaborate "cottage" is this Queen Anne/Victorian-style upscale house on Harsens Island. Away from the Harsens Island waterfront, most homes are modest and occupied year-round by the hundreds who live on the island. However, only a ferry connects to the mainland at Algonac. Considerable farming is still carried out on Harsens. (MD.)

Fishing has been popular for fun or food in the St. Clair River and Flats waters dating back to Colonial times. Commercial fishing in the area has been largely confined to the larger lakes. This turn-of-the-century photograph shows the catch of a happy couple. During the fall season, duck hunting also provides recreation. In the late-19th century, duck hunting was a commercial operation to supply Detroit's market demands. (A.)

Local development of motorboats around 1900 led to a new recreation in the St. Clair River—amateur and professional speedboat racing. This vintage photograph shows three boats speeding down the river sometime in the 1910–1915 period. The boats appear to be of similar design, but the maker is unknown. (A.)

Six
SUPPLIERS OF GOODS AND SERVICES

This historic photograph shows a virtual maritime traffic jam on the Belle River at Marine City around 1880. It symbolizes the effect of St. Clair River traffic on the local economies along the river, which created huge demand for suppliers of goods and services, both for the river traffic and to meet the needs of the area's growing population. (M.)

This World War–I era photograph of Marysville shows that the New-England-like frame house appearance of a typical St. Clair River town had not changed in many decades since that shown of Marine City around 1880 on page 21. But most of the towns along the river already had changed, and large-scale manufacturing would soon transform Marysville. (MV.)

This is a view to the south along Algonac's Water Street (now St. Clair River Drive) around 1880 (judging by the absence of utility wires). It shows brick commercial buildings including a hardware store and a grocery, horse-drawn buggies, and an unpaved street. The second-story porch on the building at the far left, the Swartout Hotel, provided a view of the river. (A.)

Here is a later view from an old postcard of what appears to be the same stretch of Water Street in Algonac as shown on the previous page. Now there are utility wires, but the traffic is still horse-drawn and the street unpaved. In the distance to the left, a water-wagon is sprinkling the street to settle dust. (A.)

This view north along Water Street again shows the brick and frame commercial buildings, the utility wires, and the buggy traffic. As in the previous two photographs, the stores fronting Algonac's main street (today's M-29) provided services to residents and river travelers alike: hotel, barber shop, hardware store, drug store, grocery store, law office, and others. (A.)

The growing villages along the St. Clair River in the last quarter of the 19th century required such municipal infrastructures as water, power, schools, and public safety to support them. This is a photograph of Marine City's "roller mill" (at left) for grain processing, and the first electric power plant, probably taken around 1890. (M.)

The invention of the modern "safety" bicycle before 1890 revolutionized personal transportation before the advent of electric streetcars or interurban and, later, motor cars. Bicycling swept the nation in the last decade of the 19th century, displacing the drudgery of having to walk and, except for the upper classes, ride a horse. Shown is a band of Marine City bicyclists, boys and men. (M.)

This is a c. 1890 view of the main street of St. Clair, Michigan, looking north. Like the views of Algonac, there are utility wires but no pavement for the sparse horse-drawn traffic. The rise to the north can be seen in the distance, and the three-story commercial buildings are notable. Today there is a shopping center at left and a riverside park on the right. (TG.)

In this turn-of-the-century photograph, the bustling town of Marine City seems almost urbanized by the arrival of interurban light-rail cars that stopped in the village on the route between Detroit and Port Huron. The "modern" two-story commercial hotel for travelers also is new. A bicycle and horse can be seen, but the motor vehicle has not yet arrived. (M.)

Among the first social infrastructure facilities of any community are places of worship. This c. 1877 illustration shows Marine City's Holy Cross Roman Catholic Church, located on South Water Street in what for a time was called "Catholic Point," the area between the Belle River and the St. Clair. The romanticized illustration may depict an earlier period of the church building. Besides churches, schools along the river were opened as early as the 1840s, when the public school movement swept the country; in some cases, private schools predated those supported by taxes. Other early governmental infrastructures included water works, sewers, and public safety—as well as organizations for maintaining land transfer records, elections, and other legal matters. (M.)

MARINE CITY,MI.1884.
WESTBROOK STORE FIRE ON SO.WATER
ST.BUILDING WAS TWO DOORS NORTH
OF PRESENT FERRY LANDING.NOW A
483-2-3 (CITY PARK)

This 1884 fire in Marine City destroyed commercial buildings along Water Street. Fires were likewise common for wooden ships, homes, and St. Clair Flat's hotels and clubs, due to the presence of kerosene lanterns and wood-burning stoves. The need for fire companies and then municipal fire departments naturally became one of the earliest infrastructure requirements in 19th-century towns. (M.)

In the larger towns, hospitals became established as professional medical training was instituted around the turn of the century. Injuries on land and water were rampant and communicable diseases struck every community. Port Huron's first hospital, with 15 beds, opened in 1882. This 1905 photograph shows Port Huron's new second hospital, providing 32 beds. That year, for the first time, a baby was born in a Port Huron hospital. (TG.)

83

Although Marine City was not incorporated as a city until 1887, three years earlier the community had erected this monumental Village Hall building, designed by famous architects Mason and Rice of Detroit, to provide a home for the new municipal services. It quickly became the City Hall. The historic structure was abandoned by city government in 2005 but is in the process of being restored (M.)

Port Huron, which became the largest city in St. Clair County, was thoroughly urbanized by the turn of the century. This historic photograph shows the view north on Huron/Military toward the Black River bridge. Note the southbound streetcar, paved street, horse-drawn traffic, and awnings over the store entrances. The awnings cooled the stores and protected them from direct sunlight. (P.)

One of the most important infrastructure components for a community is banking, to provide for deposit of funds and sources of loans for businesses and homes. This historic photograph shows the National Bank Building of Port Huron in 1903. Bank architecture called for them to look substantial, as demonstrated by the stone façade and classical columns beside the entry. (P.)

Entertainment was hardly a necessary component of the infrastructure of a community, but people demanded it, and entrepreneurs could provide it. This small theater in Marine City, dating to the early years of the 20th century, probably screened the new-fangled motion pictures—silent, of course. The Broadway Theater shown here likely was converted from a storefront or even a residence. (M.)

85

After development of the gasoline-powered automobile in the years immediately before and after 1900 and their widespread acceptance by the public, sales and service facilities spread across the country. Many originated with horse liveries, buggy dealers, or blacksmiths. This shows the substantial Dodge dealership building in Marine City and several of the new Dodge cars around 1915. (M.)

As industry developed along the St. Clair River in the 1920s and newly developed electric appliances created home demand for electricity, it was necessary for larger electric generating stations to be erected. This is a 1923 photograph of the new Detroit Edison electric generating plant at Marysville. Note the river in the background, providing easy access by water for ships hauling coal for the plant's boilers. (MV.)

By 1918, when this photograph of Water Street in Algonac may have been taken, huge changes had occurred in the St. Clair riverfront community. Motorcars and pedestrians crowded the streets. Interurban tracks were no longer apparent (though they may have entered Water Street to the north of this spot). There appear to be French flags hanging alongside the Stars and Stripes, indicating a celebration connected with World War I. (A.)

This photograph of the Ford dealership in Marine City, taken around 1920, shows how the newly developed Fordson farm tractor has displaced the horse team for moving heavy logs from forest or railroad siding to lumber mill. For comparison, reexamine the photograph at the bottom of page 54 from perhaps a mere 50 years earlier. (M.)

This is a 1942 view of Algonac's Water Street. The street is quiet, traffic non-existent, perhaps thinned by discouraging World War II news or the influence of gasoline rationing, which came late in the year. Beside the movie theater, there is a "classic" bank façade and, of course, the street is paved, as required for the state highway. Humphrey Bogart was star of the Algonac Theater's feature movie. (A.)

Five years later, Water Street is busy again, buoyed by America's World War II victory, the return of its service men and women, and the growing post-war business of manufacturing motorboats at Chris-Craft. It is not clear whether this is a Memorial Day or Fourth of July parade. Vehicles in the photograph are mainly pre-war models. The Algonac Theater double feature was led by a Marx Brothers comedy. (A.)

Seven
WOODEN BOAT BUILDERS

This undated aerial photograph from the 1960s shows, in the foreground, the giant Chris-Craft boat manufacturing plant at Algonac after company headquarters and most production had been transferred elsewhere and activity was scarce. The St. Clair River and the city of Algonac are in the background at the top of the image. Canals from the boat plant opened onto the North Channel. The property is now a marina. (A.)

Wooden boat company founder Chris Smith (1861–1939) is shown with his shotgun and the famous "duck boats" used to hunt and fish in the St. Clair Flats. He and older brother Harry were hunting and fishing guides for wealthy vacationers, also supplying fresh game to Detroit restaurants. Around 1881, clients asked Chris to build them his duck boats, the genesis of the Chris-Craft motorboat company. (A.)

Here in this modest riverside commercial boathouse on Algonac's North Channel of the St. Clair River, the modern Chris-Craft Company was established around 1900. Passenger boats such as the steam launch in the river in front of the boathouse were serviced and small boats for fishing and hunting were hand-made for clients. (A.)

Around 1902, internal combustion gasoline engines, both inboards and outboards, were introduced to small boats in the St. Clair River region. An engine mounted in a small open boat by J. Gilbert in 1906 demonstrated the amazing speed of 20 miles per hour, encouraging Chris Smith to get into the business. In half a decade, Smith produced his own early speedboat, the 1911 *Reliance III* shown here, which achieved 34 miles per hour. (A.)

Millionaire Gar Wood (1880–1971) joined forces in 1916 for a few years with craft boat builder Chris Smith to create high-speed racing boats. By the early 1920s, speed-racing trials had become a highly promoted sport in North America and Europe, in line with such events for motorcars and aircraft. This is Wood's *Miss America X*, which in 1932 achieved a water speed record of 124.91 miles per hour. (A.)

The two giants of wooden-boat building along the St. Clair River were Chris Smith (left) who founded Chris-Craft in Algonac, and Gar Wood (right), who both financed and drove the swift watercraft. Wood was a wealthy inventor and manufacturer who fancied achieving record speeds in water, buying into Smith's modest Algonac operation in 1916. The two speedboat kings parted company in 1922 when a racer built by Smith defeated a Wood boat in a Minneapolis competition. (A.)

This aerial photograph shows Wood's boat plant on the North Channel of the St. Clair at Algonac in the early 1920s. Note the seaplanes moored in the river near the plant. Wood's operation soon required a larger facility to meet the huge demand for speedboats in the decade after World War I, and he built a new plant at Marysville on the St. Clair about 25 miles north. (A.)

The 1922 Gar Wood plant layout at Marysville is shown in this image. Note that it is sited alongside the St. Clair River, with access via a small canal slip. Railroad lines bring in materials and parts, such as engines, and can carry away finished boats to faraway dealers and customers. Gar Wood exited the wooden boat building business in 1947. (MV.)

Meanwhile, Chris-Craft was doing a booming business selling mahogany-trimmed open cockpit boats like this 22-foot runabout marketed from 1927 to 1931. As noted earlier, a large demand for boats like this was created in the immediate area near the Algonac plant by both Prohibition liquor smugglers and US Treasury agents who sought to catch them. (A.)

93

Chris-Craft shipped its boats to retail dealers or customers one-by-one by truck like this in the 1920s, or by several loaded on a railcar. Many customers came right to the Algonac plant to pick up their boats by water in the access canals cut from the factory to the North Channel. (A.)

In the late 1920s, Chris-Craft introduced its cabin cruiser class of small motorboats. This weather-protected boat is shown in the slip at the Algonac plant. Note that, unlike images of Chris-Craft runabouts seen earlier in this book, this shows right-hand drive, now common in American waters. Evidently, there was no uniformity for steering position in early motorboats, just as in early automobiles. (A.)

This image shows a typical Chris-Craft dealer showroom in 1929. At left is a small cabin cruiser, perhaps 26 feet long; in the center is an open runabout, probably measuring 22 feet, and at the right is a larger cabin cruiser, as much as 35 feet long. By now, Chris-Craft also was displaying its new models at the prestigious New York (City) Boat Show. (A.)

One of the largest one-of-a-kind motorboats produced by Chris-Craft was this 48-foot "tender" built for the Mackinaw Island tourist trade in 1934, used to ferry visitors between the historic island in the Mackinaw Straits connecting Lakes Huron and Michigan and the mainland on either side. Note the two-level covered cabin; the upper for the boat crew and the lower for passengers. (A.)

Imaginative advertising and promotion was a feature of the competition for motorboat customers during Great Depression days. Here a 1935 Hudson is pictured with a Chris-Craft mounted on its top, accompanied by pretty young females, probably recruited from the office staff for the photograph. It is not known whether the Hudson Motor Company or the boat maker instigated the publicity picture. (A.)

Professional models undoubtedly were hired for this early "cheesecake" Chris-Craft publicity photograph for one of its runabouts. The photograph is undated, but probably was taken about 1937–1938, judging by the "banjo" automotive steering wheel. Note the folding, split windshield design, which may have been the news promoted by the photograph. (A.)

An idea of the tremendous production volume of Chris-Craft boat works can be gathered from this view of the lumber storage lot at Algonac late in the 1920s. The company was able to draw on lumber supplies both from Michigan and nearby Canada, as well as imported mahogany from the Philippine Islands. (A.)

In the mid 1930s, Chris-Craft was able to expand its manufacturing capacity as business got back to normal from the depths of the Depression. Here founder Chris Smith wields the shovel for the informal ground-breaking ceremony for a new building at the Algonac works. The company office (left background) and an older factory building are in the rear. (A.)

The Chris-Craft assembly operation is shown in this late-1930s photograph in the Algonac plant. At left are two parallel assembly lines for the wooden runabouts, with another line seen to the right. The company was able to draw on an experienced crew of skilled woodworkers from its earliest days around 1900. (A.)

By the time a boat reached the final trim stage in the assembly process at the Algonac Chris-Craft plant, if it was large enough or would be delivered to a customer to be "sailed" away in the water, it would be found in one of the plant's indoor slips, as in this photograph of a large cabin cruiser, taken in the post–World War II period. This boat appears to have fiberglass components, indicating it dates from the 1960s. (A.)

Eight
Manufacturing in the River Region

This large-scale model of a Morton Salt Company kitchen salt container stood outside the Marysville plant of Morton for many years. Salt was discovered in 1882 some 1,600 feet below the surface of Marine City, and numerous extraction and processing facilities were built along the St. Clair River between Algonac and Port Huron in the ensuing years. (MV.)

This historical image shows the extensive Marysville processing plant of the Morton Salt Company. Salt brine was extracted from beneath the ground of the two well derricks at left by pumping water down the shaft. In the plant, the salt solution was boiled to remove the moisture preparatory to packaging and shipping. (MV.)

An even earlier manufacturing operation along the St. Clair River was this brick factory at Marine City. Bricks to be used mainly for the exterior walls of municipal, commercial, and factory buildings were made by pressing clay scraped from the soil into molds, then baking it into usable construction supplies. Marine City's first sawmill was established in 1837. (M.)

One of the earliest types of "manufacturing" along the St. Clair River was the grain-processing mill. Lacking waterfalls to turn mill wheels in the area, entrepreneurs had to await steam-engine technology, which arrived by 1830, and could be used to power adjoining sawmills simultaneously. This view from atop the Marine City Roller Mill shows the Belle River neighborhood with two sailing vessels and warehouses across the waterway. (M.)

This image shows the new 1905-launched, steel-hulled *George H. Russel*, from a Pine River boatyard at St. Clair, near the end of the Pine's shipbuilding years, an age originally based on wooden hulls with lumber from nearby forests. Steel for hulls had to be hauled from steel mills on the far side of Detroit; steam engines also were supplied from Detroit, altogether an inefficient process, so the Pine shipyards were phased out. (S.)

Immediately to the south of the Pine River at St. Clair, the Diamond Crystal Salt Company plant was erected. In this early-20th-century image, a salt well tower appears at left, and the stacks from the steam engines that boiled the brine to be dried into table salt crystals are at right. No evidence of the boatyards of an earlier time can be discerned. (S.)

This c. 1920 photograph inside the Diamond Crystal Salt manufacturing plant at St. Clair shows workers assembling barrels in which salt will be shipped in bulk by rail cars or ships to customers. Note the overhead, belt-driven machinery powering equipment on the shop floor. The plant, much updated and now owned by Cargill, is sited on a point of land between the juncture of the St. Clair and Pine Rivers. (S.)

The largest manufacturing enterprise along the St. Clair River was created at Marysville beginning in 1919 to support production of the Wills Sainte Claire automobile. Here a snappy 1921 Wills roadster is posed for a publicity shot alongside the river. C. Harold Wills (1878–1940) was a top Ford executive who invested his fortune to introduce a new, high-tech luxury automobile. (N.)

Another motorcar manufactured in a St. Clair River community was the Havers. A touring version of the car is shown in this 1913 catalogue illustration. As an "assembled car" made from components produced by others, it was produced in Port Huron from 1911 to 1914, when the factory was destroyed by a fire and never rebuilt. (N.)

In Marysville, where entrepreneur C. Harold Wills bought almost 4,500 acres for a factory site beside the St. Clair River, construction work began quickly in late 1919. Here horse-drawn wagons haul building materials while in the background, workmen scurry over the steel framework being erected for the new auto factory. The project was a forward-looking enterprise, but the cars did not sell well, even in the Roaring Twenties. (MV.)

In this photograph from winter 1920–1921, the new Wills Sainte Claire automobile plant at Marysville has been enclosed and is almost complete. The construction project alone created hundreds of jobs in the area, and as automobile production subsequently ramped up, there appeared to be great employment opportunities for both skilled and unskilled workers. Unfortunately, the project was short-lived, although the facility had a long history. (MV.)

This image of the interior of the Wills plant as it geared up for production in 1921 shows the extensive installation of equipment to machine engine camshafts for the forthcoming auto production. Note the spaghetti of belts descending from the long shafts atop the rows of machining equipment, an inefficient means of power soon to be replaced in factories by electric motors. (MV.)

Here new 1922-model Wills Sainte Claire motorcars exit from the final assembly line, where finishing touches were applied before the models were shipped to distributors and dealers. Wills cars came in a variety of body styles including open roadsters and touring cars and closed coupes, sedans, and limousines. Custom bodies were produced elsewhere and shipped to Marysville. The Wills make folded by 1927 after producing only 12,107 cars. (MV.)

C. Harold Wills thoroughly embraced the early-20th-century concept of "welfare capitalism" when he established high quality housing for his employees near the relatively remote (from population centers) Marysville auto plant in 1920–1921. This image shows a row of Wills auto company apartment houses and community facilities within walking distance of the new factory. Wills personally worked on the construction of these buildings. (MV.)

Shown here are examples of the single-family residences under construction at the Wills Sainte Claire "company town" near the manufacturing and assembly plant. Wills's Marysville Land Co. hired Detroit contractor Walbridge Aldinger to erect such houses. The architect is unknown. Employees could rent these homes or buy them on an installment plan. Many are still standing with few modifications after 90 years. (MV.)

After the Wills automobile company failed, several entrepreneurs tried to use the Marysville facility for other manufacturing, including marine and industrial engines. Another effort was made in the early 1930s by the Buhl Aircraft Company of Detroit, which had a hangar (shown here), assembly facility, and airfield at the northwest corner of the huge plant. (MV.)

This full-scale model of the Buhl "Bull Pup" airplane hangs in the Wills Sainte Claire museum in Marysville. It was a single-place, low-wing monoplane. Introduced in the depths of the Great Depression, it had little chance of success. The originals were built at the former Wills plant. None are known to survive, hence this locally constructed reproduction. (MD.)

The life of the former Wills plant on the St. Clair River shore was far from over after a series of failures, however. Around 1935, the plant was purchased by Chrysler Corporation to manufacture industrial and marine engines, basically conversions of passenger car engines—the latter to be installed in small boats like Chris-Crafts. This aerial view shows the Chrysler Plant in 1955, still in operation 20 years later. (C.)

This photograph shows Chrysler employees working on marine engines at the former Wills auto manufacturing plant in 1955. In the 1980s, Chrysler largely withdrew from the marine engine business, but converted the plant to what is now the company's National Parts Depot, supplying dealers with the complete array of replacement and repair parts for Chrysler, Dodge, and Jeep vehicles. (C.)

Nine
OTHER TRANSPORTATION

This aerial photograph from the 1960s shows the ferry dock, US customs gate, and downtown Marine City. The ferry provides a shortcut to Ontario on the opposite side of the St. Clair River and continues in use. Marine City today is little changed from this photograph, having avoided much of the urban renewal of the 1950s that altered the waterfronts of nearby Algonac and St. Clair. (M.)

The "Iron Horse" steam railroad connected to Port Huron just before the Civil War, the first modern alternative to steamships on the St. Clair River. When later tied to Canadian rail lines, the cars were ferried across the river on specially built ships (page 34). This image shows a Grand Trunk Railroad predecessor work train on the Detroit–Port Huron line at the Clinton River bridge near Mount Clemens late in 1859. (KH.)

This historic image shows the Grand Trunk Railroad's Port Huron station, built in 1859 to accommodate Detroit passengers. Rail lines ran from Port Huron to Detroit and points south, and others ran across Michigan directly to Chicago via Flint and Lansing or to ferry ports on Lake Michigan for crossings to Wisconsin. On the Canadian side, steam rail service connected to Toronto, Niagara Falls, and Buffalo. (KH.)

This 1894 map shows railroad lines emanating east and west from Port Huron, when rail service was at its peak. Light-rail interurban trolleys were just beginning to serve the St. Clair River communities, and the motorcar was, in effect, a decade in the future. The 1891 rail tunnel under the river at Port Huron provided for "trunk line" service from Toronto through to Chicago. (P.)

Train Service Between DETROIT and PORT HURON

Grand Trunk Railway System

READ DOWN			STATIONS	READ UP			
No. 33 Daily	No. 29 Ex. Sun.	No. 17 Daily	(Effective February 11, 1917) Central Time	No. 38 Ex. Sun.	No. 12 Ex. Sun.	No. 8 Daily	No. 14 Daily
PM	AM	AM	Lv. PORT HURON Ar.	AM	PM	PM	AM
*7.10	†10.30	*6.10		†8.45	†5.10	*9.15	*2.10
†7.26		6.25	SMITH'S CREEK	8.30	4.55		
†7.33		†6.31	COLUMBUS	†8.22	†4.47		
7.44	11.00	6.46	RICHMOND	8.10	4.35	8.40	†1.36
7.54		6.56	NEW HAVEN	7.58	4.25		†1.26
		†7.05	CHESTERFIELD	†7.48	†4.14		
8.14	11.25	7.15	MOUNT CLEMENS	7.38	4.04	8.14	1.11
†8.22		7.24	FRASER	7.24	3.50		
		†7.39	MOUNT OLIVET				
			FOREST LAWN				
8.48	11.59	7.53	MILWAUKEE JCT.	6.58	3.23	7.43	12.33
9.04	12.14	8.09	GRATIOT AVE.	6.46	3.11	7.31	12.21
*9.15	†12.25	*8.20	Ar. DETROIT Lv.	†6.35	†3.00	*7.20	*12.10
PM	PM	AM		AM	PM	PM	AM

Light Face Type—A. M. Bold Face Type—P. M. *Daily. †Daily Except Sunday. ‡Stops on Signal.

A timetable for Port Huron–Detroit travel via Grand Trunk Railroad in the early 20th century shows that express service with stops only in Mount Clemens and Richmond took less than two hours; even a "local" required little more than two hours. As shown on page 64, a Detroit-to-Port Huron river steamer could take six hours or more because of many stops at hotel and park docks along the way. (P.)

111

In 1891, because of delays and inefficiencies crossing the St. Clair River on special rail ferries, the Canadian National Railroad opened a tunnel under the river between Sarnia and Port Huron, the first such in the world. Initially, steam locomotives pulled cars through the tunnel, but it was found the fumes were dangerous and unpleasant. This image shows a steam engine emerging from the tunnel in Port Huron. In 1908, there was a change from steam to electric locomotives for tunnel power and today diesel locomotives are used. In later decades of the 20th century, as rail cars became too large to pass through the tunnel, and before enlargements and eventually replacement of the original tunnel, the rail line found it necessary to revert to ferries to carry oversized rail cars across the river. (P.)

This turned-on-its-side map covering the northern part of the Rapid Transit interurban line between Detroit and Port Huron shows the relationship of towns and waterways from a "bird's eye" view looking east. From left to right, the meandering Black, Pine, Belle, Pine, Salt, and Clinton Rivers cross the landscape, requiring bridges for the light-rail cars. The Interurban line reached Port Huron in 1899 and was abandoned by 1930. (M.)

This shows the first bridge, a turnstile, over the Belle River in Marine City, erected in 1873. Adequate for buggies, horses, pedestrians, and bicycles, it allowed shipping upstream to the right. The St. Clair River was downstream about a half-mile. Judging by the launch at left and the bicycle, the photograph was taken in the 1890s before the interurban line required a new, heavier bridge. (M.)

The iron bridge over the Pine River at St. Clair, shown in this view looking north, was required for the heavier interurban cars and rails. Interurban cars provided quick and inexpensive transportation for vacationers and weekenders, even commuters, as well as farmers who could ship their milk and other produce to markets in Port Huron, Mount Clemens, and Detroit. But the unforeseen popularity of private motorcars doomed them. (S.)

The huge counterweight lift bridge over the Black River in Port Huron was built to accommodate full-scale railroad locomotives and cars on the Grand Trunk track alongside the St. Clair River. This contemporary photograph shows the view looking west from the river towards downtown Port Huron. The bridge has been preserved as an industrial artifact, although the rail line has long been closed. (MD.)

The State of Michigan, like other states, got into highway construction in the 1920s. The six-mile-long paved road through the St. Clair Flats, M-154, dates from 1931. State highway M-29, shown in this 1940 image, has followed the same riverside drive route through St. Clair County since 1939. Its original construction across marshlands utilized some old interurban roadbeds, according to local lore. (H.)

The Highway Department's biggest pre–World War II project was the Blue Water Bridge connecting Port Huron with Sarnia, a project started in 1938. This photograph shows work on the giant concrete footings for bridge piers sunk into the shore on the Michigan side of the span near the head of the St. Clair River. The earliest road in the area was the 1818 Military Road (Gratiot) from Detroit. (H.)

This dramatic photograph shows that three of the bridge spans are completed, but there are huge gaps awaiting hook-up to cross the river. This view looks east across the St. Clair River. The Blue Water Bridge proved to be a huge economic bonanza for both Port Huron and Sarnia, especially when truck traffic increased dramatically following the United States–Canadian North American Free Trade Agreement of the 1960s. (H.)

Stringent border security measures instituted by US Customs following the terrorist attacks of 2001 were compounded by the increase in vehicle traffic across the Blue Water Bridge, and compelled construction of a new side-by-side span in 1997. This view to the west down the newly paved span contrasts with the 70-year-old bridge at right. (H.)

This contemporary aerial photograph of the twin-span Blue Water Bridge shows it crossing the narrowest part—less than 500 yards—of the 40 mile long St. Clair River. At its western end in Michigan, the bridge connects to Interstates 69 and 94 and US 25. In Ontario, the bridge funnels traffic to and from Canadian 402, a divided, limited-access, multilane highway comparable to US interstates. (DK.)

This sign is the colorful marker for the ferry between Algonac and Harsens Island across the North Channel. At Harsens Island, the ferry meets Michigan state highway M-154, which crosses numerous bridges over canals to the gate of the Old Club property at the southern end of the St. Clair Flats. (MD.)

At a turnoff from M-29 in Algonac, cars and trucks await vehicles clearing the Harsens Island ferry so they can board. The ferry operates around the clock and through the winter, although it can be blocked by ice in the channel. This presents a problem for the island's young people, who in recent years have attended mainland schools. The trade-off for islanders is living in perpetual vacationland. (MD.)

At Algonac's other ferry dock, this sign with its glaring punctuation error awaited travelers in the left lane to Canada's Walpole Island and, at right, the car-free American Russell Island. Russell Islanders must find a place to park their vehicles in Algonac while they are vacationing or visiting island cottages. (MD.)

Ten
Transformations

The modest 92-foot, diesel-powered *Diamond Queen* day cruiser, along with a few sister boats, is all that remains of the fleets of excursion boats that once cruised between Lakes Erie and Huron. Here it is shown loading passengers for a Memorial Day weekend cruise to and from Detroit and Lake Huron. Detroit's Renaissance Center towers are in the right background and Windsor, Ontario, at left rear. (MD.)

Although its 19th-century clubhouse burned down many decades ago and styles have changed, the waterfront of the Old Club at the southern end of St. Clair Flats has changed little in appearance over the course of more than a century. The cottages still rest on stilts, closely packed together. Some remnants of 19th-century architecture remain, such as the tower on the cottage at left. (MD.)

Fire continues as a threat even in the 21st century, despite the fact that building occupants no longer depend on kerosene lanterns and wood-burning stoves. This image shows the "burn out" of an upscale waterfront cottage a short distance from the Old Club. Only the stone chimney remains from a "controlled fire" that reportedly got out of hand. Today's fire fighters, like those of a century ago, are still far away. (MD.)

The South Chan'l Yacht Club shown here fills the former quarters of a historic small hotel, remembered under several names from the 19th-century vacation resort age. Today the property provides a marina for medium-sized cabin and cuddy cruisers where members keep their boats and vacationers can stay for extended periods during the tourist season. The club bar presumably stays busy, too, during the season. (MD.)

This photograph shows the Idle Hour Club, once Idle Hour Hotel and before that Riverside Hotel in the late 19th century (see page 70). It is the only remaining large hotel structure from the golden age of resort hotels along the St. Clair River. The tall tower contains remotely controlled surveillance equipment for Homeland Security to watch for illegal immigrants crossing the river. (MD.)

Here is Water Street in Algonac, as it appeared in 2010. At left is the one-time doctor's residence and office, now housing the Algonac–Clay Township Historical Society Museum. In the center behind the trees is the US Customs office at the Walpole-Russell ferry dock. Most of the 19th-century buildings gave way long ago to urban renewal and the riverfront park. (MD.)

This magnificent Greek Revival mansion with its second-floor porch and columns, located on the west side of Algonac's Water Street, was torn down years ago. A Dairy Queen occupies the site in 2010, more welcome to the people enjoying the park and river views across the street than its classical predecessor. (A.)

Further south on the west side of Algonac's Water Street is this large Queen Anne–style house, dating to the late 19th or early 20th century. Many such buildings have survived as bed-and-breakfasts or tourist homes, but the river view location also has invited substantial investment in restorations and updating, whether for investment or personal enjoyment by residents. (MD.)

What was once Algonac's Water Street is today more fancily labeled St. Clair River Drive. This center-entrance residence with second-story porch has been restored but still maintains the classic features of its more-than-century-old design. The house, like the other historic but contemporary Algonac homes pictured here, faces the St. Clair River across the street and the park. (MD.)

As previously noted in these pages, Marine City has managed to retain much of its historic 19th-century streetscapes. This image shows brick storefronts along the west side of Marine City's Water Street. From a different angle, an old advertising sign might be discerned, painted on the two-story side of the corner building in the background, yet the trees along the sidewalk provide a modern look. (MD.)

Marine City's oldest building was built in 1847 for the Newport Academy. Later it served as village hall, a church, fire station, again a school, the library, and, since 1983, Marine City Historical Society's Pride and Heritage Museum. Oddly, it is not located close to the river, but rather two blocks inland on Main Street, once the interurban route coming north from the Belle River Bridge. (MD.)

Directly across Main Street from the museum on the previous page is this magnificently restored Greek Revival home in the style favored for residences of the wealthy in towns along the river. David Lester, a pioneer shipbuilder in Marine City, began the mansion in 1855, the year his first ship was launched, but did not complete it until 1885. (MD.)

Marine City's Belle River meanders all the way from Lapeer, some 60 miles away in the next county to the west, to where it enters the St. Clair in the distance here. The now peaceful Belle was once the location of the busiest shipyards along the St. Clair River (page 77). Now it is a quiet waterway fronted by enclosed marinas, private docks, and—for the most part—lawns. (MD.)

Similarly, marinas berthing fiberglass-hull pleasure cruisers now occupy the Pine River at St. Clair, also once the site of busy shipyards. This image shows the salt processing plant in the distance, still south of the Pine, except that the giant Cargill Corporation owns the facility rather than the longtime locally-owned-and-managed Diamond Crystal Salt Company. (MD.)

St. Clair's waterfront today presents a pleasant riverfront park, attracting day visitors or—at the adjoining St. Clair Inn just to the north—overnighters. A hundred years ago, though, the town's waterfront was a typical commercial stretch of docks, warehouses, and merchants, as shown in this vintage postcard. At left can be seen the stacks of the old Diamond Crystal Salt company. (MS.)

126

BIBLIOGRAPHY

Bloomfield, Ron. *Maritime Bay County*. Charleston, SC: Arcadia Publishing, 2009.
Corwin, Harney and Edward Fynmore. *Black River Canal*. Charleston, SC: Arcadia Publishing, 2005.
Creamer, Mary Lou. *Port Huron: Celebrating Our Past 1857–2007*. Sight Creative Inc., 2006.
Cregg, Joan and Martin Morganstein. *Erie Canal*. Charleston, SC: Arcadia Publishing, 2001.
Crown, Barbara. *Historic St. Clair River Hotels and Resorts*. Privately published brochure, undated.
Davis, Michael W.R. and Clare Snider. *The Ford Fleet*. Cleveland, OH: Freshwater Press, 1994.
Dixon, Michael M. *When Detroit Rode the Waves*. Mervue Publications, 2001.
———. *Life at the Flats*. Mervue Publications, 2002.
Dowling, Rev. Edward J., S.J. *The "Lakers" of World War I*. Detroit: University of Detroit Press, 1967.
Earle, Rosamonde H. *Life and Times in Early St. Clair, Michigan*. Privately published, 1973.
Eddins, O.N., DMV. *Mountains of Stone*. Afton, Wyoming: privately published, 2008.
Homberg, Charles. *St. Clair, Michigan*. St. Clair Historical Commission, 2007.
Mason, Philip P. *Rum Running and the Roaring Twenties*. Wayne State University Press, 1995.
McElroy, Frank. *A Short History of Marine City, Michigan, 1929*. Reprinted 1980 by Marine City Rotary Club.
Mollica Jr., Anthony S. *Boats of the Antique Boat Museum*. Clayton, NY: Antique Boat Museum, 2006.
Rodengen, Jeffrey L. *The Legend of Chris Craft*. Write Stuff Syndicate, 1998.
Seestadt, Katheryn. *A History of Cherry Beach*. Privately published, 1977.
Theisen, Harry W. and Katherine D. *Russell Island, Remembrance of Things Past*. Russell Island Press, 1985.
Tompert, Ann, ed. *The Way Things Were, an autobiography of Emily Ward*. Marine City: Newport Press, 1976.
Algonac Community Centennial, 1867–1967. Updated 1993.
Catalogue. Bay City: Aladdin Homes, 1914.
"Gar Wood Sets A New World Record, September 20, 1932." *Algonac/Clay Township Historical Society and Museum Newsletter*. June 2007.
Grosse Ile Historical Society. *Grosse Ile*. Charleston, SC: Arcadia Publishing, 2007.
St. Clair Shores Historical Commission. *St. Clair Shores*. Charleston, SC: Arcadia Publishing, 2001.
Sentries in the Wilderness. Port Huron: Museum of Arts and History, 1986.
Year of the Tunnel. St. Clair River Tunnel Centennial Committee illustrated calendar, 1991.

Discover Thousands of Local History Books Featuring Millions of Vintage Images

Arcadia Publishing, the leading local history publisher in the United States, is committed to making history accessible and meaningful through publishing books that celebrate and preserve the heritage of America's people and places.

Find more books like this at
www.arcadiapublishing.com

Search for your hometown history, your old stomping grounds, and even your favorite sports team.

Consistent with our mission to preserve history on a local level, this book was printed in South Carolina on American-made paper and manufactured entirely in the United States. Products carrying the accredited Forest Stewardship Council (FSC) label are printed on 100 percent FSC-certified paper.

MADE IN THE USA